Text by Miisa Mink and
photos by Milla Koivisto

Font and flavour

Scandinavian moments with Nordic Bakery

Foreword

Font and flavour succinctly captures what Nordic Bakery has grown into over the years since I fully took on this labour of love. "Font" not only captures our distinctive use of Helvetica since the bakery's inception, but it also so perfectly highlights the essence we place on designing the space as a whole. Not every coffee shop could claim that! And "Flavour" is not only obvious in the taste of our baked goods and coffee, but it also offers a deeper view into the flavour of what 'Nordic' means. In this book you get a little glimpse, a little flavour of Nordic 'silence and beauty'.

Those also happened to be the two words resonating in my ear when I walked into our founding store, in the heart of Soho for the first time. Silence and beauty. The coffee shop on Golden Square had been open for a year and was founded by a fellow Finn, Jali Wahlsten. I immediately fell in love with the concept and wanted to be involved. I had just left a busy career in international advertising, developing a lot of very noisy brands and was looking for something that would temper my soul.

Jali has since left the business but the work he began – to create a peaceful meeting place in a frantic city – is even more relevant today than it was in 2007 when Nordic Bakery launched. We have since expanded in London and the brand has evolved, but the core elements of beauty and silence remain the true ethos of Nordic Bakery.

Today we live lifestyles with increasingly accelerated tempos, and with this, it is my firm belief that collectively and individually, we as humans need to seek out and steep ourselves in beauty; in well designed spaces, and to nourish ourselves by the spoonful with heart warming, honest food.

While we become entrenched by the demands for increased economic efficiency via speed and mass production, we seek to create the opposite. Nordic Bakery sweetly fuses attention to detail with a passion for freshly baked cakes, and harmony brought forth by the smell of cinnamon buns straight from the oven.

Nordic Bakery brings the graciousness of unused space to a city where every square inch is exploited. Silence is a welcome refuge; a walk in the atmospherically rich and absorbent Finnish forests and fields of untouched nature. We may not always be the most talkative of nations, but from silence stems our ability to see and express beauty in simplicity and to actively and serenely listen.

Within these pages I hope to offer you a glimpse of this world by illustrating the harmony and essence of Nordic Bakery. Stay silent. Stay open and enjoy the moments with Nordic Bakery.

— Miisa Mink, co-owner, Nordic Bakery

Childhood dreams in sugar and spice

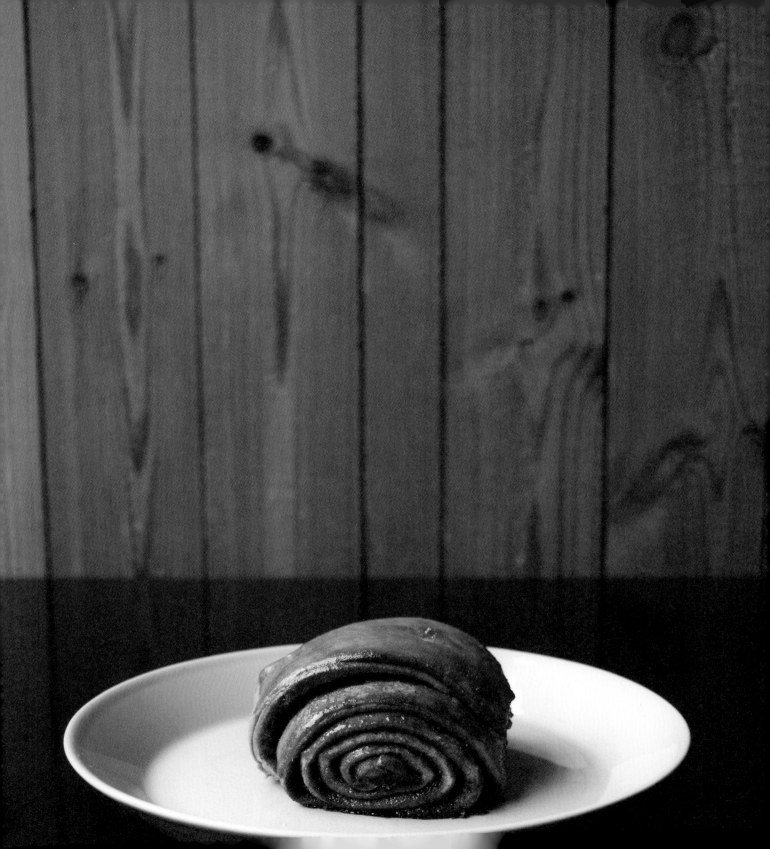

There is an art in the rolling of the dough,
which should never be too loose or too tight,
but possess just the right amount of elasticity
and malleable tension.

At the heart of our bakery lies the edible hallmark of our identity – the cinnamon bun, hundreds of which we bake from scratch every day. Our own version of this classic has its roots in Helsinki, where I am from, and has often been the initial hook, line and sinker to our most long standing and frequent patrons. Each day we follow the same recipe and exact proportions in order to create a taste of fortifying and honest goodness in every cinnamon laced bite. The result is a beautiful, structured pastry defined of multiple overlapping layers sectioned by the simple ambrosia of spice and sugar. That sweet and spicy aroma fills the bakery throughout the day as new batches come steaming from the oven. After a short layover in their cotton clothed baskets they become someone's morning or afternoon delight.

It's a privilege to present this traditional product in contemporary urban London. Each batch is a reminder of childhood memories of my grandmother pulling out a tray of cinnamon buns from her oven with a long wooden spatula. The scent of which filled me with gleeful childhood expectation. What an exquisite smell that is. They were always served warm and with a cup of milk. Tucking in to each layer, the melting dough, complimented perfectly with the thinner layers of intense but never overpowering sweetness. It is a pleasure and responsibility to re-create these little culinary delights day after day to the many patrons who appreciate them just as much as I did when I was a child in Finland.

There is an art in the rolling of the dough, which should never be too loose or too tight, but possess just the right amount of elasticity and malleable tension. When perfectly baked, the amber syrup drips ever so gently from the bun. The opening taste of cinnamon, followed with the subtler notes of cardamom.

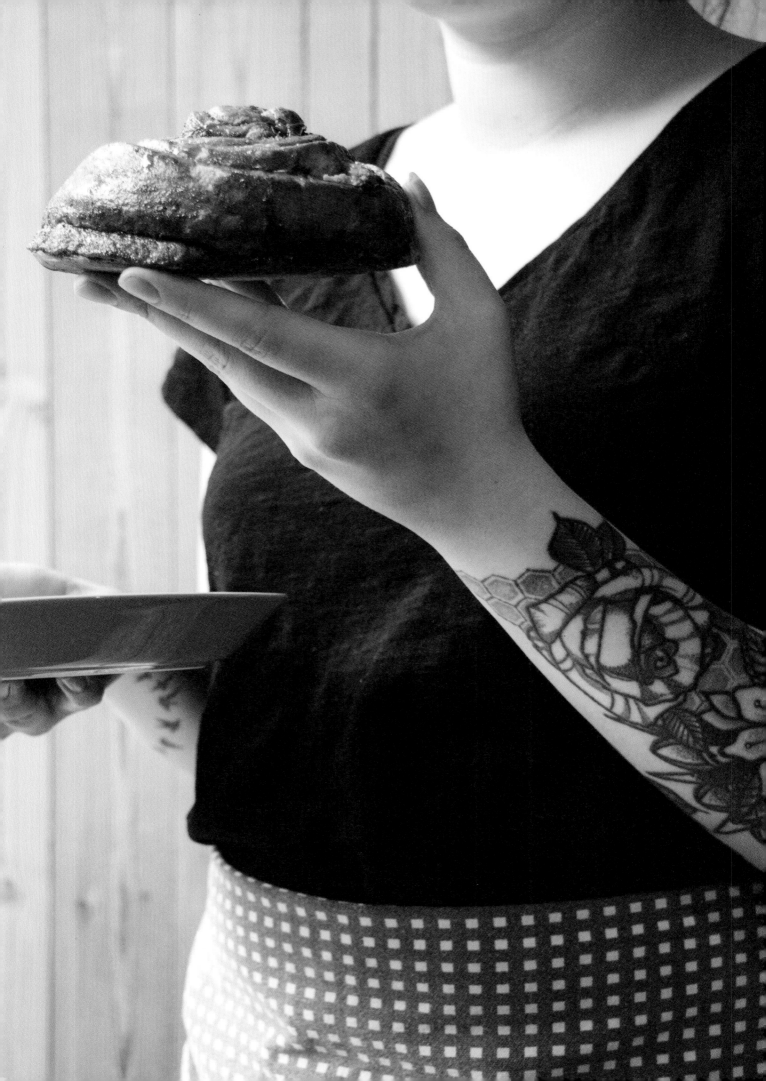

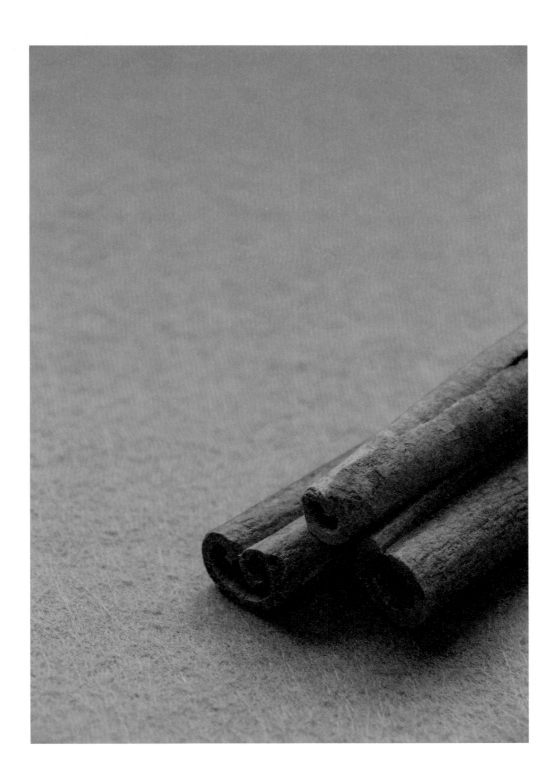

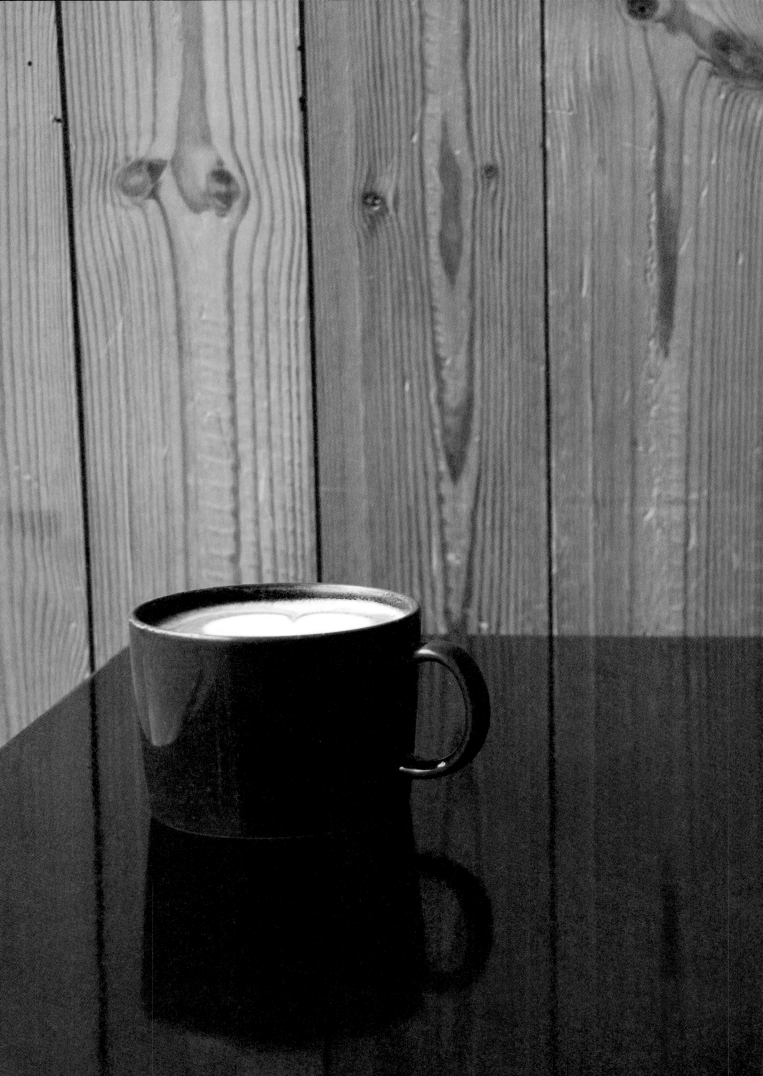

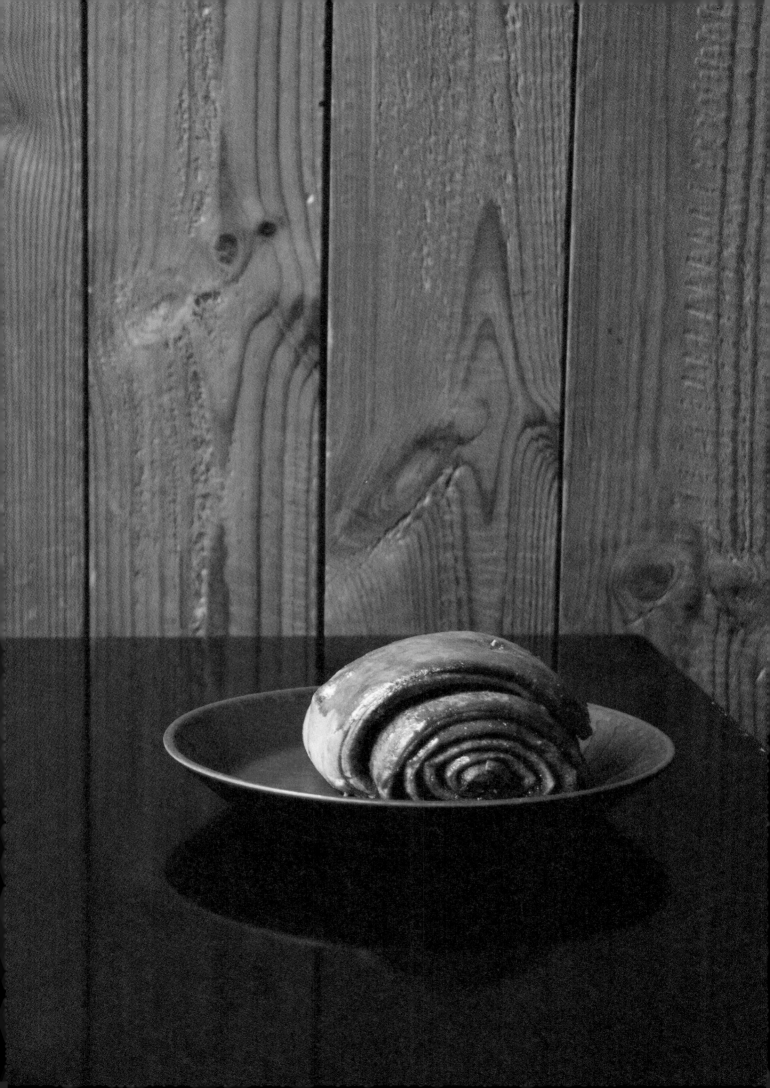

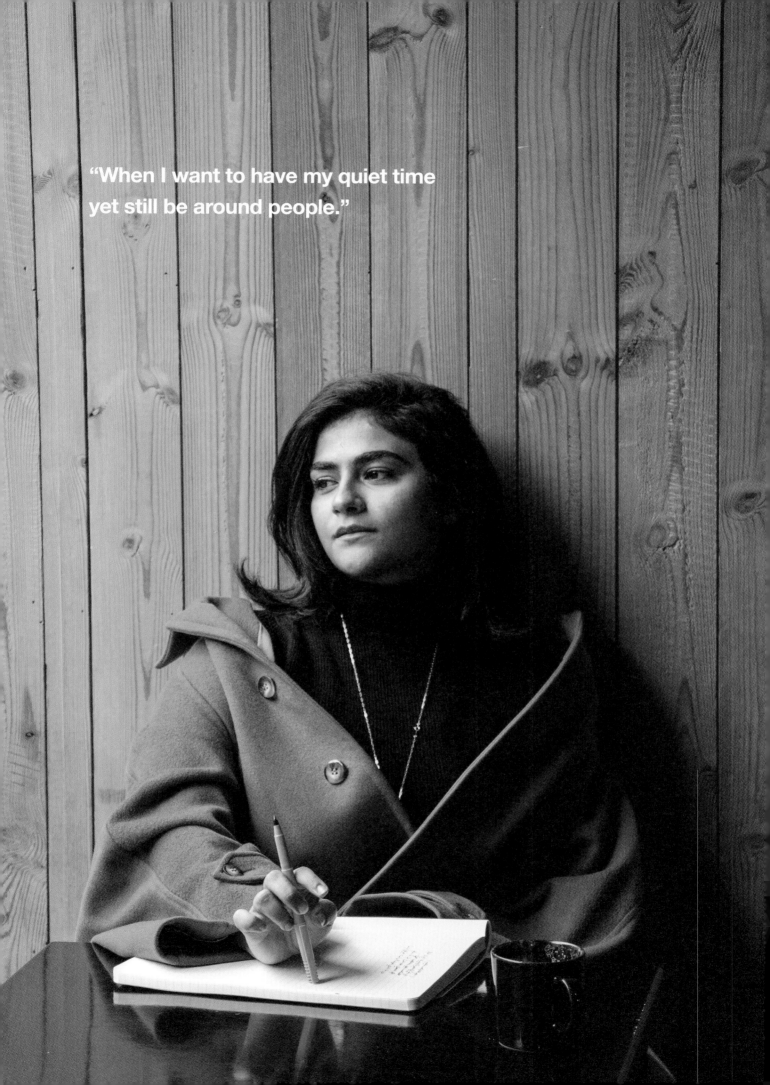

"When I want to have my quiet time yet still be around people."

A good place to be alone together

"The first time I walked into Nordic Bakery it was to try their famous cinnamon buns. The second time I walked in was when it became home to me. We all try to find that one place in the public sphere that feels like home, and offers that sense of familiarity. I had been searching for a quiet place within walking distance from my house to work on my dissertation when a friend of mine suggested this place. Ever since then, I come to Nordic Bakery when I want to have my quiet time yet still be around people."

Amira appreciates the counterpoint atmosphere shared between the up-tempo of London and the languid mellowness found in the bakery. "London is always busy, crowded, and loud. As much as I love the energy of the city, it can get overwhelming. Nordic Bakery however is quiet and calming. I think it might be the only café in London that doesn't play any kind of music. The only sounds you hear are people conversing, the mechanics of coffee beans grinding and your keystrokes as you type. I love it. London's weather does complement the setting of Nordic Bakery. If it's rainy and gloomy outside you walk into the café and it feels like you've entered a fire-lit cabin in the mountains. When it's sunny and bright outside, the effect is mirrored inside the café as well."

Studying full time can often mean intense pressure and workload. While Amira comes to the bakery because she wants to be alone, she has noticed that she is not alone in her mindset. "When I am here, I notice that no matter how diverse the people that come into the coffeehouse are, everyone is on the same slow, yet productive pace. Everyone respects one another's private space, in a friendly manner. I don't know if it's me or the nice weather, but I get a lot of friendly smiles when I'm there – and they are always much needed!"

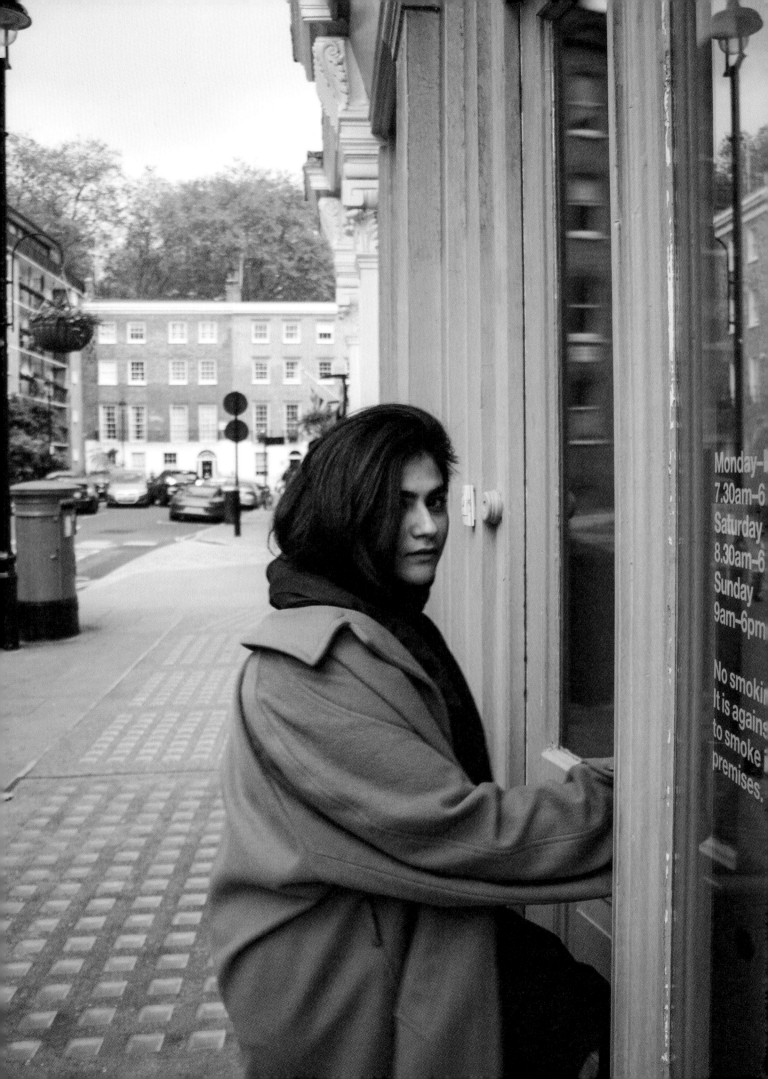

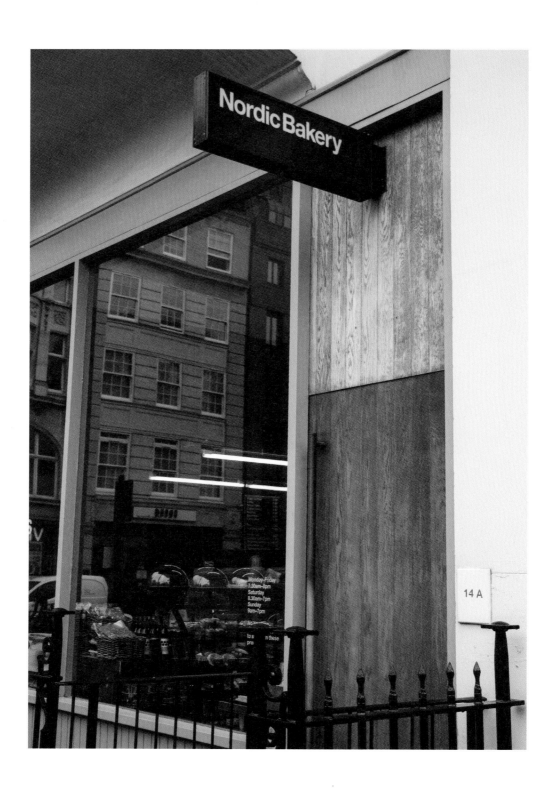

Designing
the urban
Nordic escape

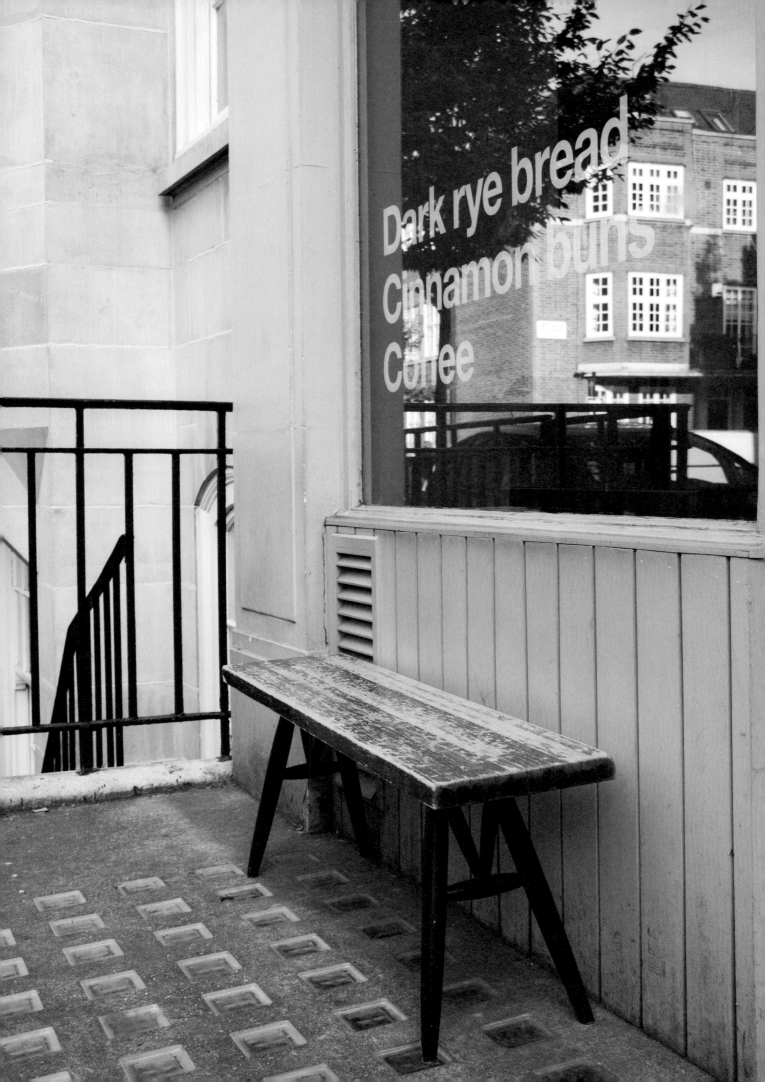

Our work embodies designing an experience for every person that crosses the threshold of Nordic Bakery. A defining component of this lies in each facet of our design. Every element is thoughtfully considered to provide our patrons with the sense of warmth and re-centering. Every taste, every colour and every texture is contemplated in terms of excellence, quality and sensory appeal. We make it our mantra: Essentials only.

Evident inspiration from iconic Nordic designers, such as Kaj Franck, Alvar Aalto and Ilmari Tapiovaara is apparent. Every piece of furniture, art and element of tableware is authentic, carrying with it its own unique story. Together they create a fused harmony and refined simplicity. The few select design elements integrate with the open sound space, which is left free for natural acoustics to inspire an internal and external tuning down and peacefulness. We want our patrons' eyes to relax into the details – the texture of the staff aprons, the softness of the textile hung on the wall, the high gloss of painted tables, the grain of the wood.

Honouring capaciousness extends to the two dimensional space as well. We ink the essentials and allow the majority to remain unmarked, preserving a place for reflection and contemplation. Our identity is texted in Swiss font Helvetica for its continual contemporary timelessness. It perfectly captures our ethos of simplicity and order. Font and flavour.

Each Nordic Bakery carries with it its own colour palette in Nordic Noir style. While Scandinavian style is often a symbol of light and airiness, Nordic Bakery provides the Northern counterpoint offered in evening shades. Hues that celebrate what's intense and deep: rich forest greens, baked reds and the blue at dusk. A signature shade to honour each of the Nordic Bakery outposts.

Beauty is food for the soul. One moment at a time.

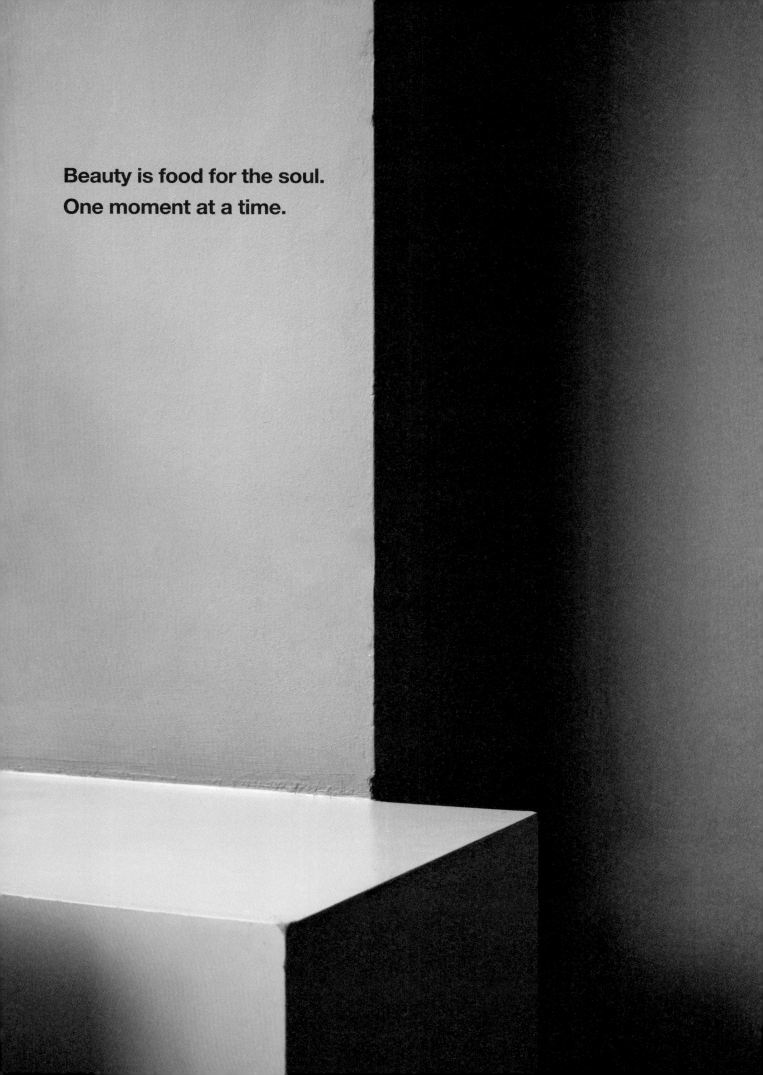

Beauty is food for the soul.
One moment at a time.

Scandinavian light
Nordic noir

One is blessed with light but we choose to pull down the evening shades of Nordic Noir. It is from this spacious and splendid region in which we channel our identity and which fuels our penchant for quietude. We dream of chiaroscuro painted lakes surrounded by snowy peaks that fade into a sky drained of all colour. We walk through cold and uncharted paths amid lush pines with the crunch of snow beneath our paws. In our minds, wander the thoughts anticipating the promise of hearth and fire awaiting us at journey's end.

Whether we people the cities or dwell in the sprawling forests alongside fauna, we are a population of born listeners. Listening to nature is one of our earliest teachings. Silence, when you choose to listen attentively has much to say and offer. It's this silence we hold precious and work so actively to share with you, our patrons. The Nordic region is gracious in its ability to calm and instil peacefulness and appreciation for our shared home. Upon the forest floor grows the velvety moss, the golden mushrooms and bursting forth with verve at the just precise moment: the richly hued berries which strike the perfect balance between tart and sweet.

The natural light makes its daily journey, shifting silently from one hue to the next. With each turn of the fader, we adjust with it, trackers of the sun and shadows. The light falls down and dusk ushers in the magic hour; that perfect time for fika and the lighting of the candles.

Scandinavia resides within us, offering us space when we need to spread out our thoughts, inspiring us to put them them back together in orderly fashion, just like the pine trees in the Finnish forest.

Solitude. Warmth. Simplicity and silence. The Nordic way.

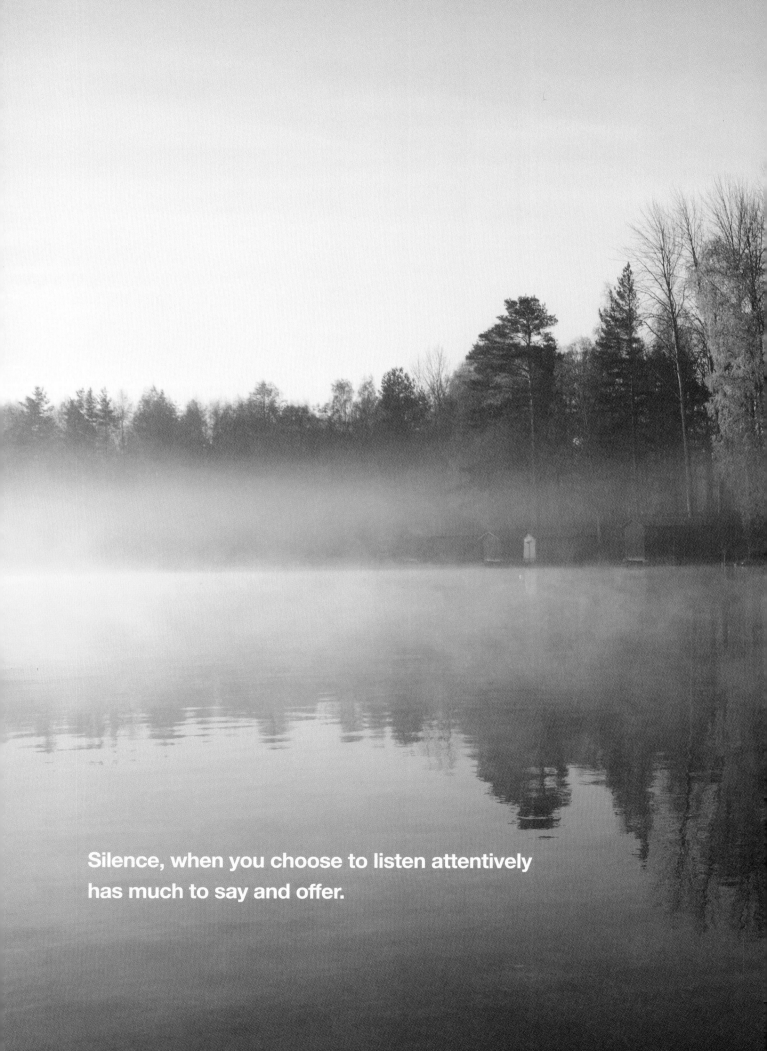

Silence, when you choose to listen attentively
has much to say and offer.

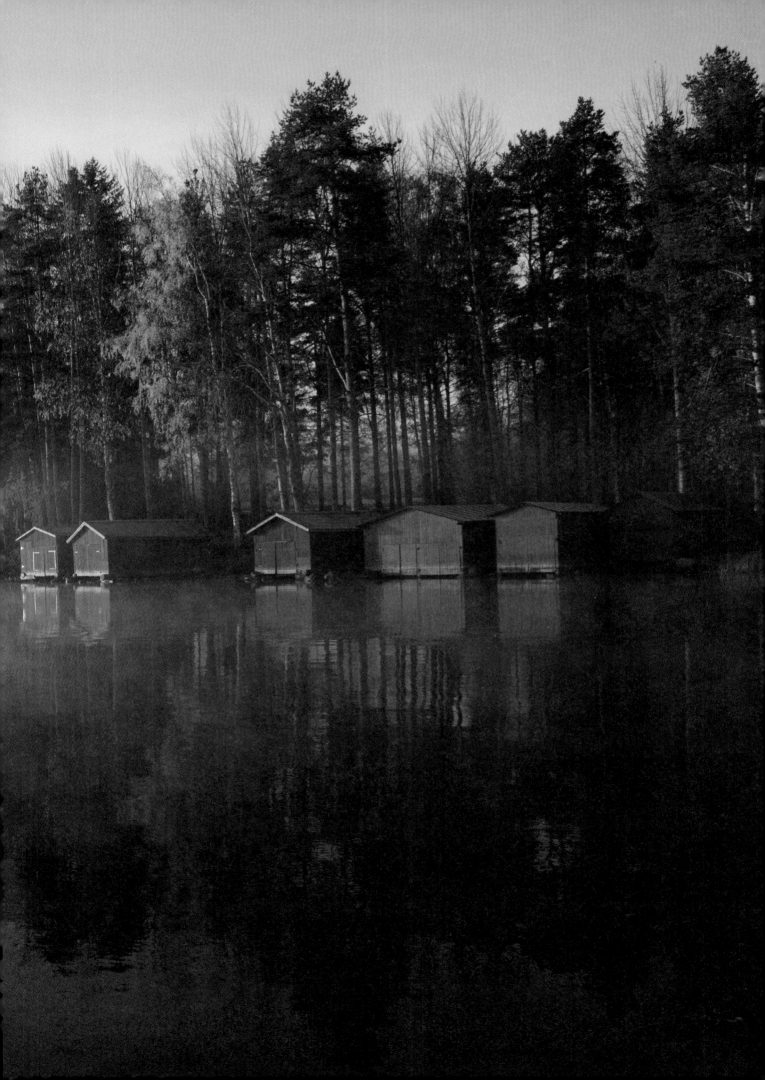

The
colour
of rye

Believing what's easiest is not always the perfect way out, or in. Such is the case with the classic Finnish rye bread, which requires everyone and every effort, to pitch in just a little bit more. We are however big believers in its worth, not just for its deep and satiable qualities but for its unique taste and high nutritional content. Due to its deep roots, rye is able to absorb more nutrients and at the same time it prevents erosion of the soil. This makes it a perfect crop for organic farming since rye reduces weeds naturally without the need for pesticides.

Rye takes more time to make and to consume but also gives in equal measure. Naturally filled with fibre, vitamin E, calcium, iron and potassium, rye is not only incredibly nourishing for the body but also flavour complex, creating a unique and interesting dark note for the palette.

It's one of the most typical of Nordic grains, not to mention one of the oldest. It's honest and hardy, just like the Nordic attitude. With such a strong personality, it easily captures our attention with interest. In some areas of Finland, rye is the preferred bread of choice, precisely due to its bold and fearless flavour. Unlike other bread types, rye is not a fast passing bread but one that is like a meal unto itself – both in its presence and as a food.

We choose to round out our rye open sandwich taste pairings with traditional Scandinavian combinations that highlight the food's simplicity and exemplify the fine quality of each single ingredient. Nothing more, nothing less. Enjoy the marinated smoothness of Gravad lax, or the sweetness of brie and lingonberry counterpointing with the caraway notes of the earthy rye and enjoy a perfect melange of taste combinations.

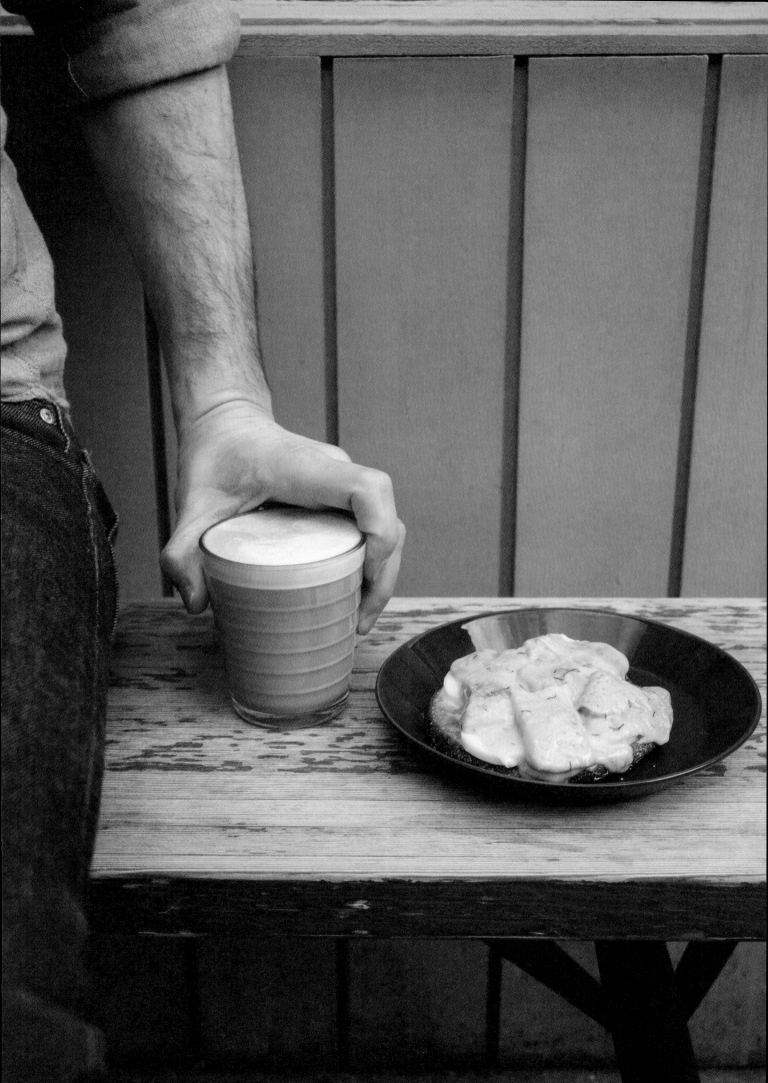

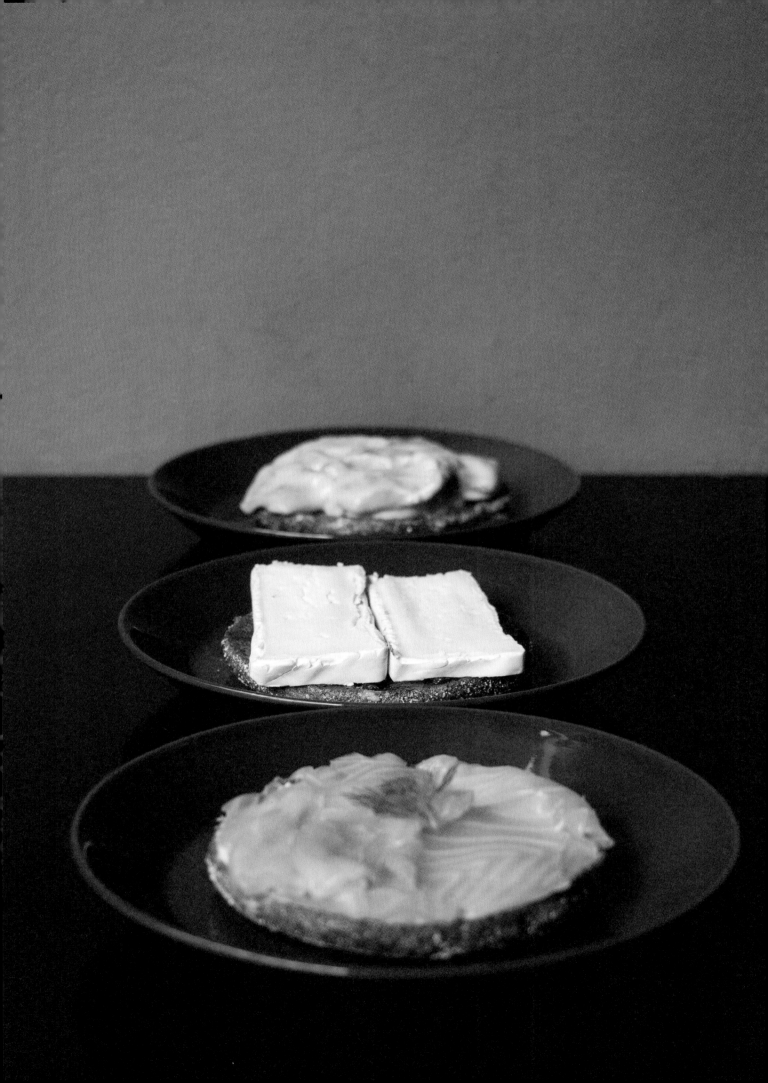

Egg and herring

Spread dill mayonnaise onto slices of dark rye bread. Add slices of hard-boiled egg and pickled mustard herring. Add a sprinkle of finely chopped chives.

Brie and lingonberry jam open sandwich

Spread Nordic Bakery 80% lingonberry jam onto slices of dark rye bread and combine it with brie cheese.

Smoke salmon open sandwich

Spread dill mayonnaise onto slices of dark rye bread. Layer smoked salmon on top. Add a small stalk of fresh dill.

Rye takes more time to make and to consume but also gives in equal measure.

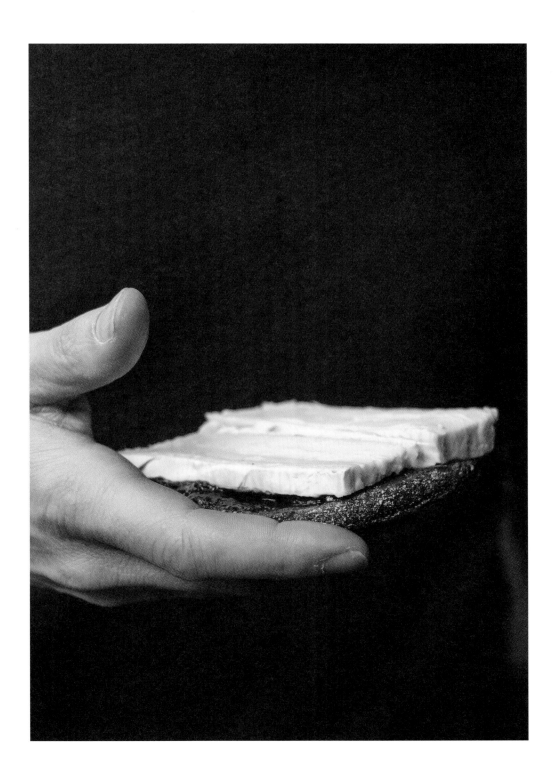

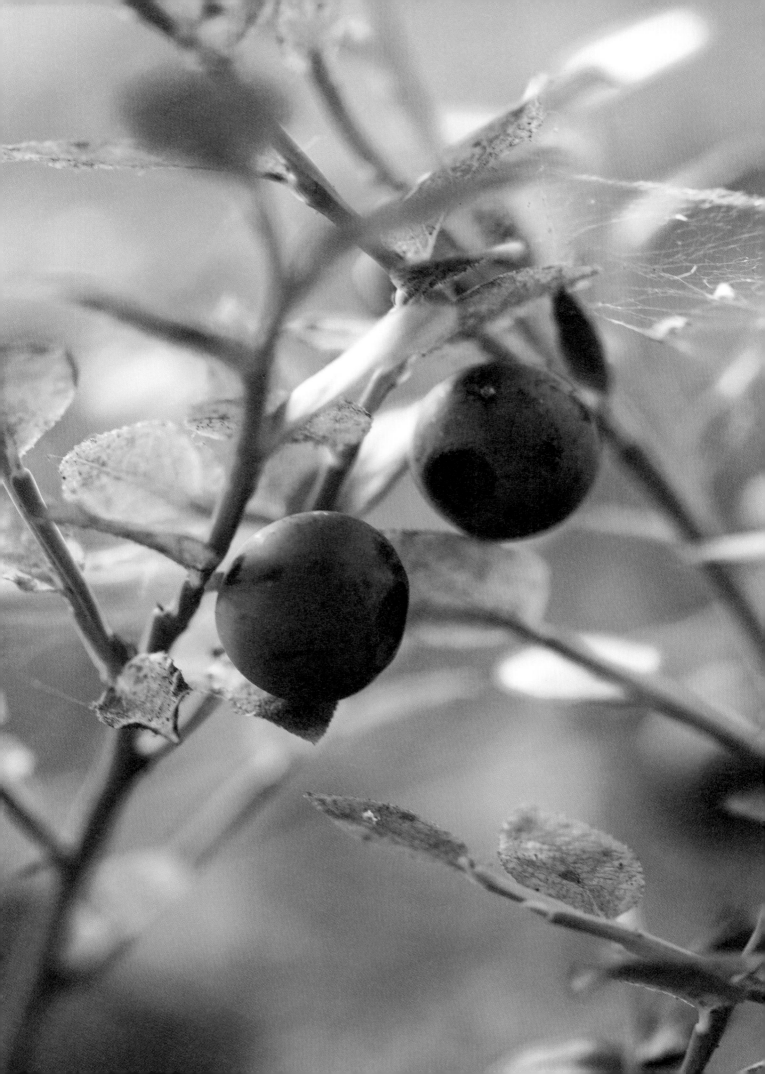

Wild berries foraged from immaculate forests

We work with small family producers in Finland who supply us our cordials and jams. They are longtime, reliable Finnish suppliers, many whom have had berry picking in their blood for generations, and who know the dense forests like the back of their hands; the same ones which pick each and every berry that goes into the cordials and jams they produce. Finland is well known for being one of the greenest and cleanest regions in the world, populated with immaculate and magnificent forests. With that honour comes the pleasure of producing some of the most flavourful berries on the planet.

The jams we use and serve come from Hommanäs Manor which is now run by the latest in the family lineage, Magnus Andersson. Founded in the 16th century, Hommanäs is situated in the Finnish archipelago in Porvoo, not far from Helsinki. What makes the jams a flavour parade is their exceptionally high berry content. That, and the complete omission of additives or preservatives which allows the intense flavour of the berry to shine through with every bite.

While the season for berries is rather short, wild berries possess a power with which cultivated berries can't compete due to the long extending summer days. Wild blueberries have a higher anthocyanin content than cultivated berries – this is the flavonoid which gives them their super antioxidant properties and is responsible for the deep blue colour.

Our cordial producer, Aten Marja-Aitta also provides us with equal flavour intensity courtesy of their cold-pressed cordials. Their freshly picked lingonberries and blueberries are immediately frozen. At the point of production, they are thawed, pressed and then quickly heated to above + 85 °C and then bottled with expediency. This process produces vibrant summer flavours all throughout the year.

Both the jams and cordials offered at Nordic Bakery follow our ethos of authenticity, simplicity and honesty. What you see is what you get.

Wild berries possess a power with which cultivated berries can't compete due to the long extending summer days.

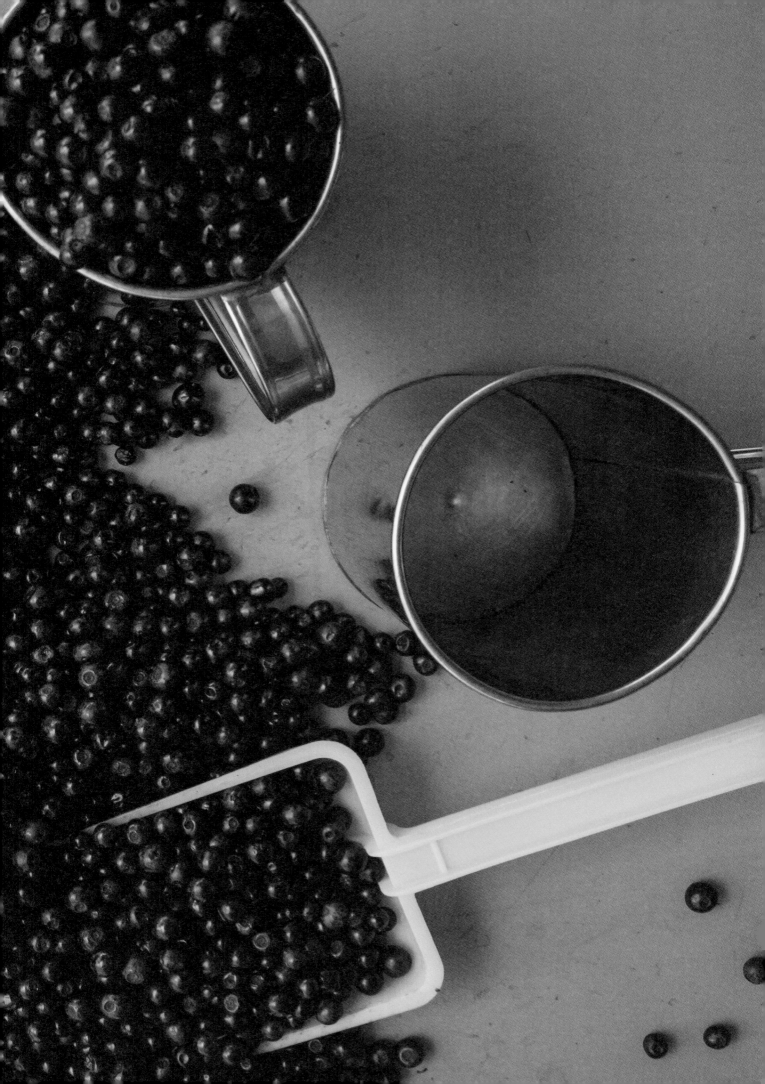

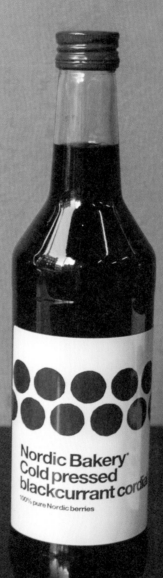

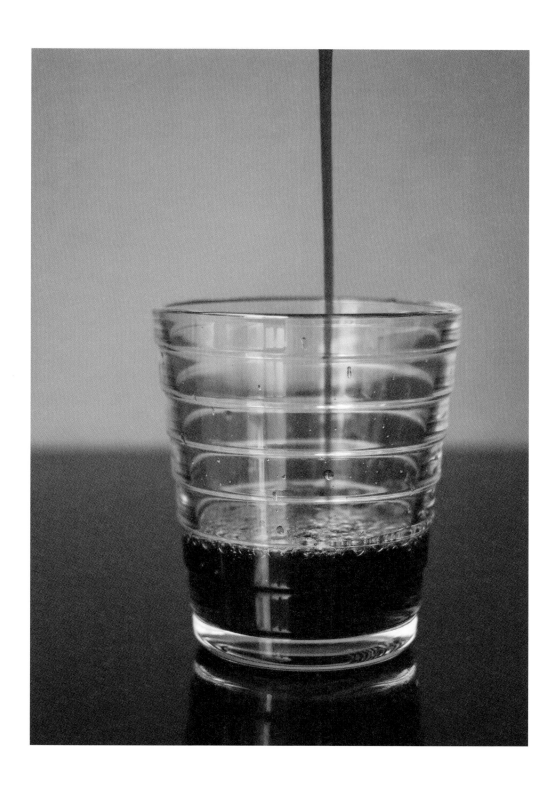

Wearing black drinking coffee

A creative making their mark in the lively city of London can often find them-selves in need of a calming refuge in which all the thoughts that are darting around have an inviting landing zone so they can settle down and sort them-selves out. It's this that we aim to achieve each day even before we open our doors; kneading the dough and sending the aroma of spices into the air. We provide an uncluttered environment for contemplation of the mind and satia-tion of the senses.

One such creative who has found a refuge in Nordic Bakery is entrepreneur Efe Çakarel.

Says Efe, "It's our official company canteen and second office. Being a very creative team, and being a fan of Scandinavian design personally, Nordic Bakery found me, actually." Efe is founder of MUBI Films, an online art house streaming service. Efe is a self-professed "eccentric patron who's there at the same time every morning wearing black, sipping coffee quietly, deep in thoughts."

On how they met: "It's our official company canteen and second office. Being a very creative team, and being a fan of Scandinavian design person-ally, Nordic Bakery found me, actually. It's right in the heart of Soho, which is London's pinnacle of the arts and media hub, so it's always buzzing and a great place to meet partners and incredible people. I think it's an amazing place. They say coffee is the drink of philosophers. Whenever I really want to think I go to Nordic Bakery."

Having grown up in Turkey and having also lived in the US, Efe remarks, "I love every minute of living in London; this city has a huge amount of creative talent. Therefore, nurturing and championing that talent is vital to business while being able to live in a huge hub that sparks global ideas."

"What I like is simple: great coffee, great food, great wine and great films. My life and work combine all these elements so I am very lucky."

Monday–Friday
7.30am–8pm
Saturday
8.30am–7pm
Sunday
9am–7pm

No smoking.
It is against the law
to smoke in these
premises.

14 A

"What I like is simple: great coffee, great food, great wine and great films."

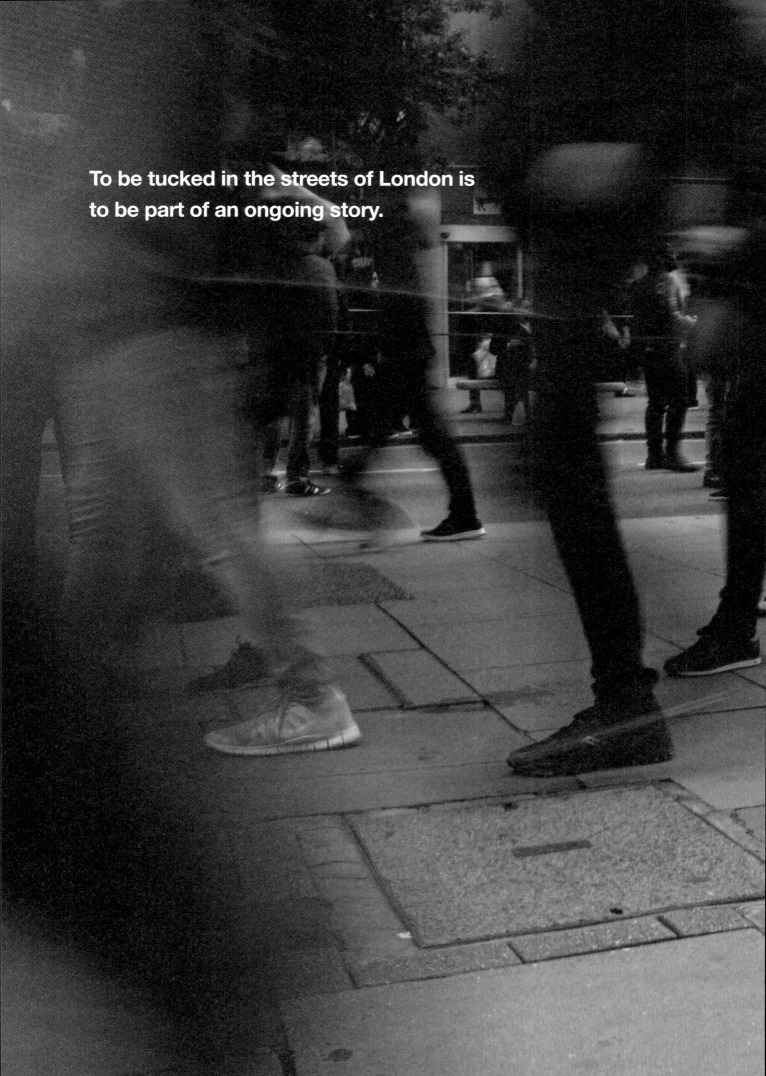

To be tucked in the streets of London is to be part of an ongoing story.

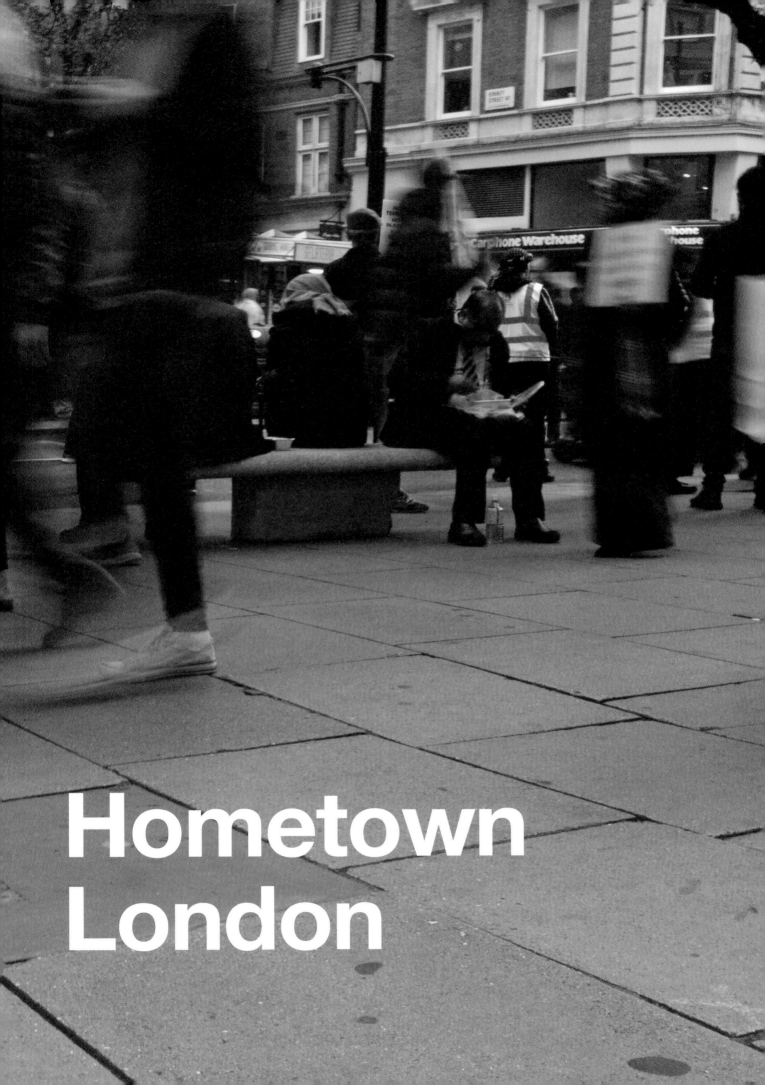

Hometown
London

"If you are tired of London, you are tired of life." — Oscar Wilde

While our family tree extends back to our Finnish roots, we are very firmly planted in London's richly cultivated soil. We are a London brand and London is our home. We take pleasure in providing Londoners repose from their dynamic lifestyles one cinnamon bun and cup at a time. Unlike any other city on Earth, London pulses with its many unique charms and characteristics that feed us just as much as we feed its eternally hungry residents.

Filled with options and opportunities to those who are ready to seize them, you can be who you are, genuinely and freely. Embracive of a global array of cultures, personalities and styles, there is always an abundance of experiences and flavours to sample. It's this city that planted the seed for us to grow and blossom, one outpost at a time. We love to be the punctuation between the many highlights of the world's finest art, design and music. There is always something new and surprising happening and we feed off this energy as much as the next person. We are a city populated with leaders in their fields; an incredible pool of talent with a partiality for what's most discerning – be it food, art, or knowledge.

To be tucked in the streets of London is to be part of an ongoing story, one that we take pleasure in reading and contributing to with every new day. Magic abounds at every turn if you have the vision and desire to see it.

We offer an elixir to patrons when it's time to let fall out and untangle the many thoughts and feelings such a city inspires. We create a place in which to sit quietly, to gaze out the window and slowly reflect on such energy and its machinations sans the constant humming of the hive.

We are a rest area for the London soul.

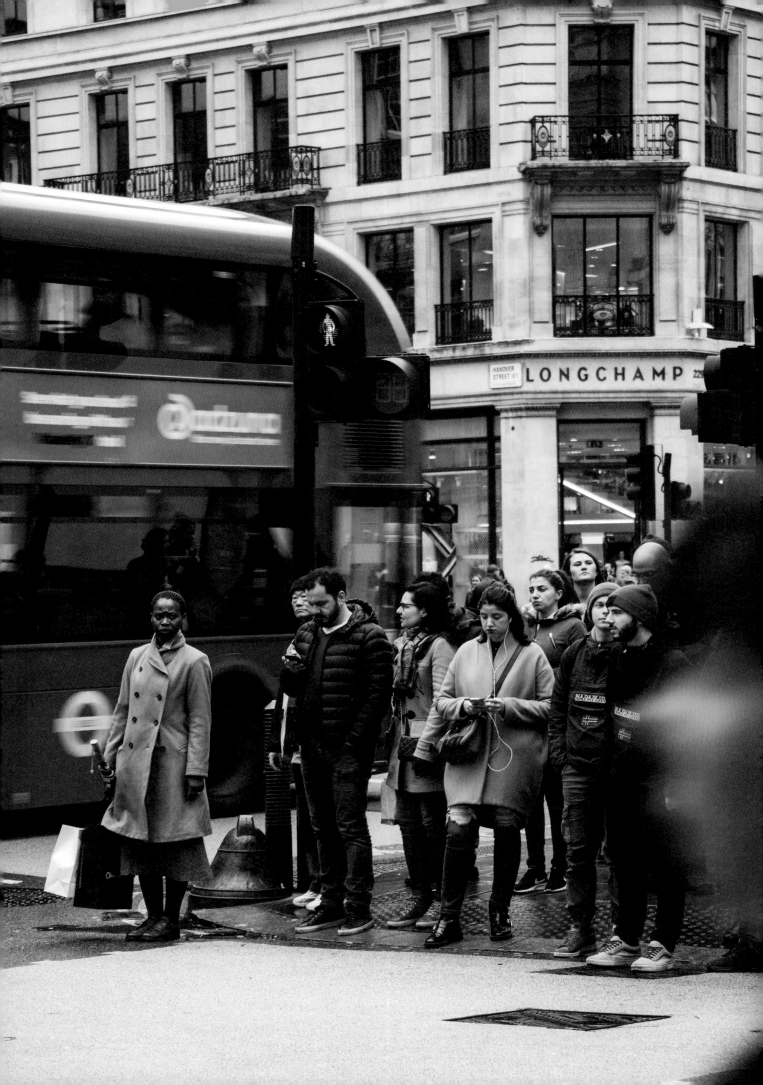

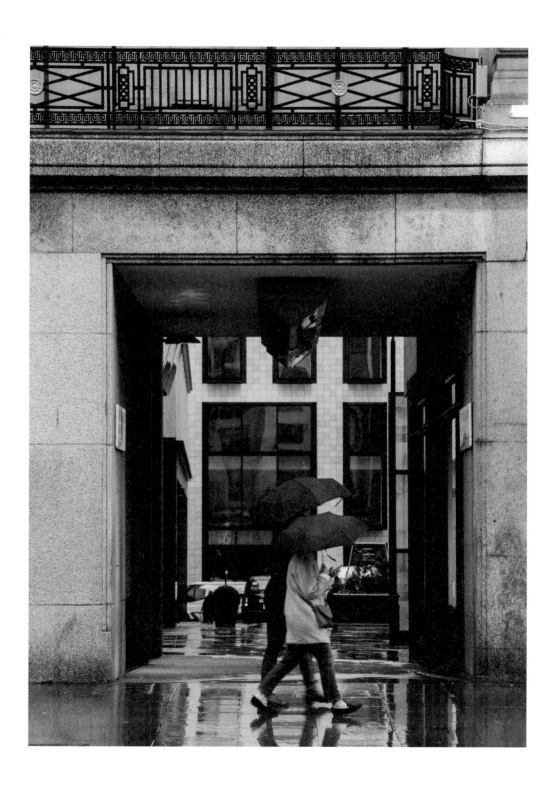

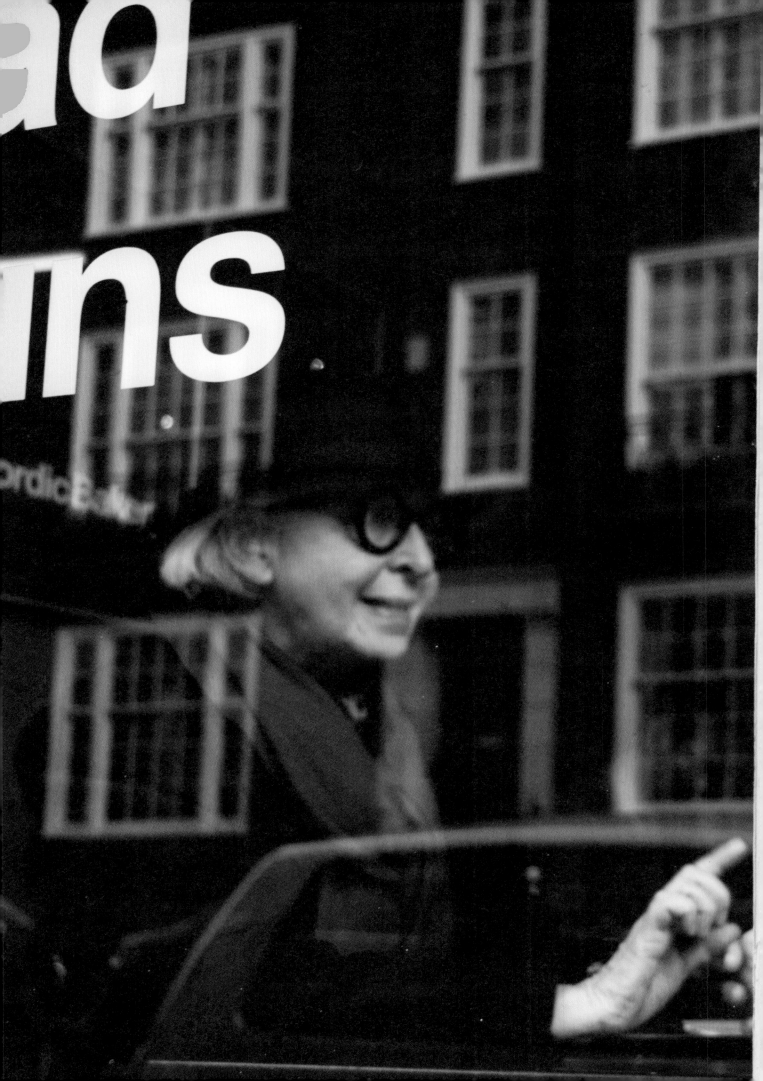

9am–6.30pm

No smoking.
It is against the law
to smoke in these
premises.

Dates
and spice
Essentials
in the Nordic
pantry

Too often, fine baking and fancy cupcakes woo visually, only to disappoint with a mouthful of nothing but sugar.

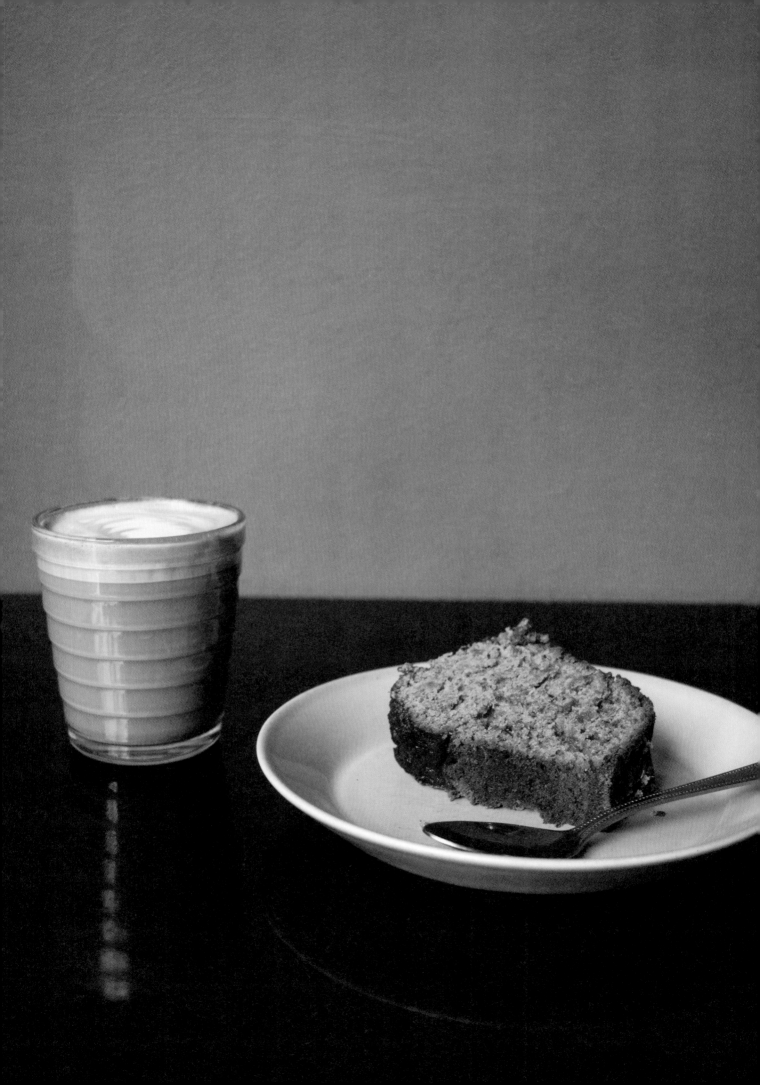

Rich with the seeds, nuts and fruits from nature's harvest – there is a satis-
fyingly raw, homemade quality to Scandinavian cakes. That's because they
don't rely on flavour and colour from E-numbers and colourings. Nordic baking
uses spicy flavours and real spices. Nordic cakes are 'real'.

The Nordic way of cooking showcases natural ingredients in their natural
presentation, rather than trying to produce a glossy turned out art piece. It is a
celebration of different flours (we often bake with rye flour, spelt, and oatmeal),
real butter and organic eggs, enriched with the natural sweetness of honey,
wild berries and fruit.

Too often, fine baking and fancy cupcakes woo visually, only to disappoint
with a mouthful of nothing but sugar. At Nordic Bakery, we prefer to appeal to
all the senses and use aromatic ginger, cardamom, cinnamon, cloves or citrus
notes from lemon and orange to tempt before taste.

Texture is important too, so we might add nuts (such as almonds which form
a lovely crunchy topping for one of Sweden's best loved cakes – the Tosca
cake), poppy seeds and oats. Crushed beets and grated carrot often lend a
moistness and earthy colour. The aim is to make every mouthful both simple
and satisfying, as a visit to one of our cafés will testify.

Date Cake

Preheat the oven to 180 °C (350 °F) Gas 4.

Heat the dates and water in a saucepan and mix well. While gently boiling mash the dates. Cook until it makes a paste and all water has evaporated, roughly around 10–15 minutes.

Add the butter and sugar while the paste is hot so that it melts and mixes well. Transfer into a bowl and set aside to cool down.

Once the date mixture has cooled down, add the eggs one by one, whisking well after each addition. Add the vanilla extract and mix well.

In a separate bowl, sift the baking powder, bicarbonate of soda and flour together, then fold into the mixture.

Spoon the mixture into a prepared cake tin and level the top with a back of the spoon.

Bake in the preheated oven for 50–60 minutes, or until the cake is firm to touch and a skewer inserted in the centre comes out clean.

Date cake keeps for several days in an airtight container.

Makes 12–16 slices

350 g dates, pitted
300 ml water
210 g plain flour
1 teaspoon baking powder
1 teaspoon bicarbonate of soda
10 ml vanilla extract
200 g unsalted butter
270 g caster sugar
3 eggs

a 23-cm bundt tin or 22-cm loose-bottomed/springform cake tin, greased

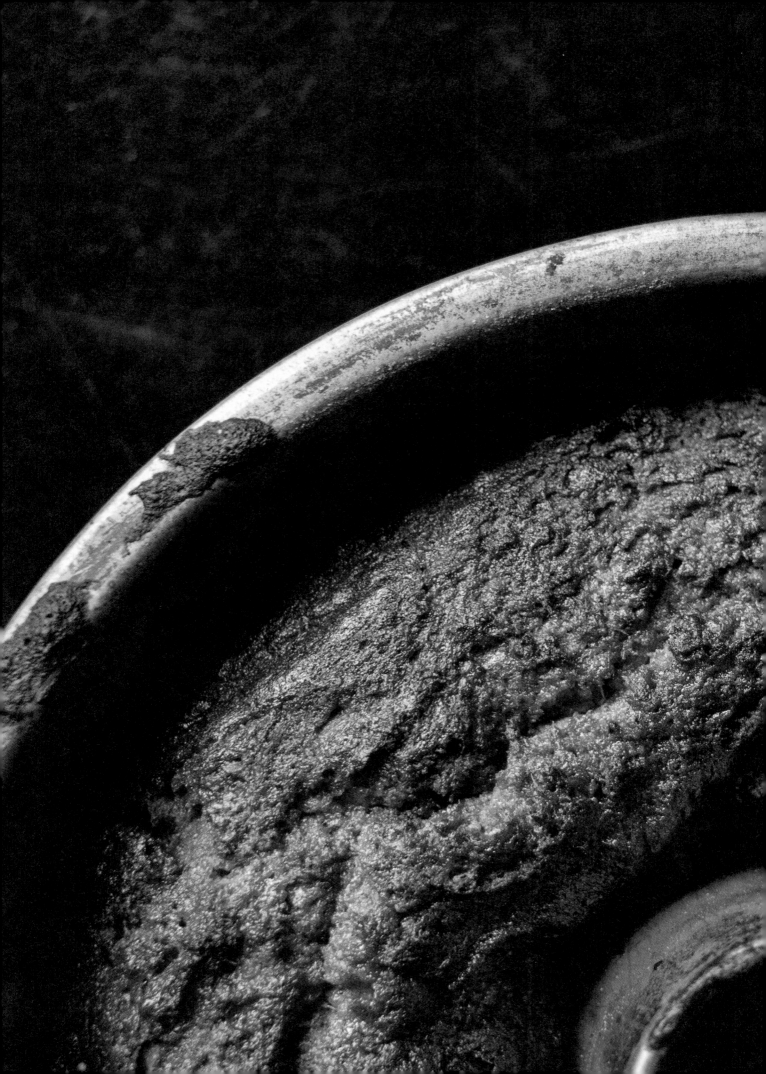

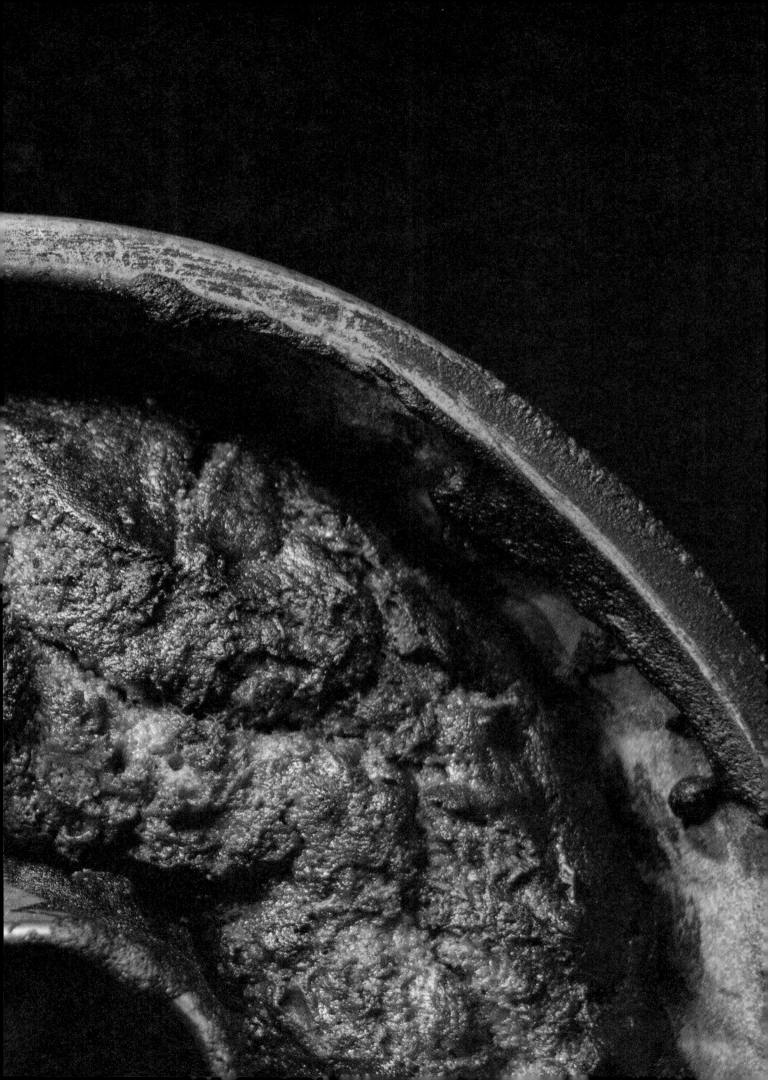

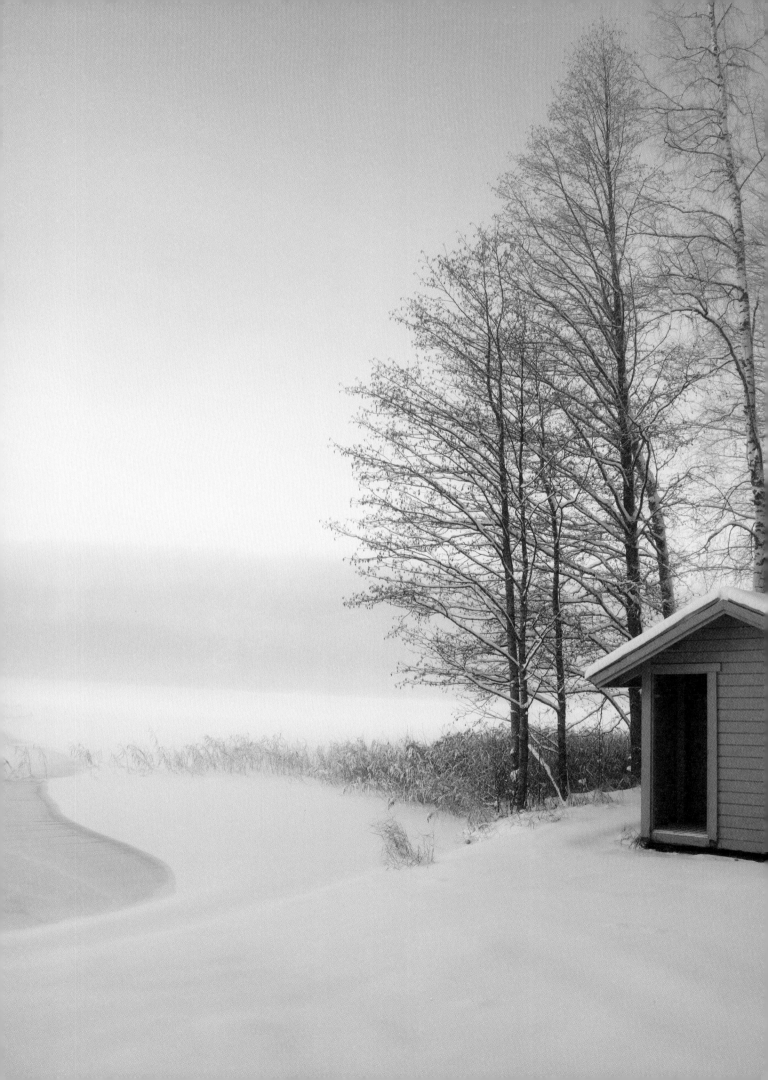

The art
of reduction

We continually create Nordic Bakery to intentionally shift the senses the moment your arm reaches out to pull open the painted door. It's a tempo and key change for ears and eyes, taste and touch. From Nordic Bakery's inception, it has been our motto to remove all which we believe is gratuitous, leaving optimal space for the primary purpose – restoration and relaxation from frenetic city living. We achieve this state by seeking out every potential for impression and distraction, sculpting it down to the bare essentials. It is a practice of continually reducing diversion in such ways that make Nordic Bakery unique.

We offer an acoustic space left open for natural sound elements, a promotion-free environment, a single serving size, a spare use of (originals only) art, a non-intrusive service staff, treating our patrons as intelligent human beings, a scaled down complementary menu with even prices. If it's £3, it's not £2.99.

Each of these elements highlight what we do choose to offer: quality, authenticity.

Thereby amplifying the space for you and your moment of relaxation.

Reducing sensory input allows more time for nuance to be experienced and quality to be enjoyed. It allows the eyes more time to focus on the shift from being outdoors to a quieting interiour. The ears become more finely tuned to detail and nuance, tuning into the sound of your coffee being made, and to what your companion is thinking and feeling. Your taste buds and sense of smell become piqued with the aroma of spices and freshly baked bread. Your sense of touch delights as your hands wrap themselves around a warming cup, or as you try and resist the urge to doodle upon the steamed up window.

This practice in reduction affords each person we honourably serve more time to spin cohesion into their own thoughts and reflections.

Every element considered. Continuously.

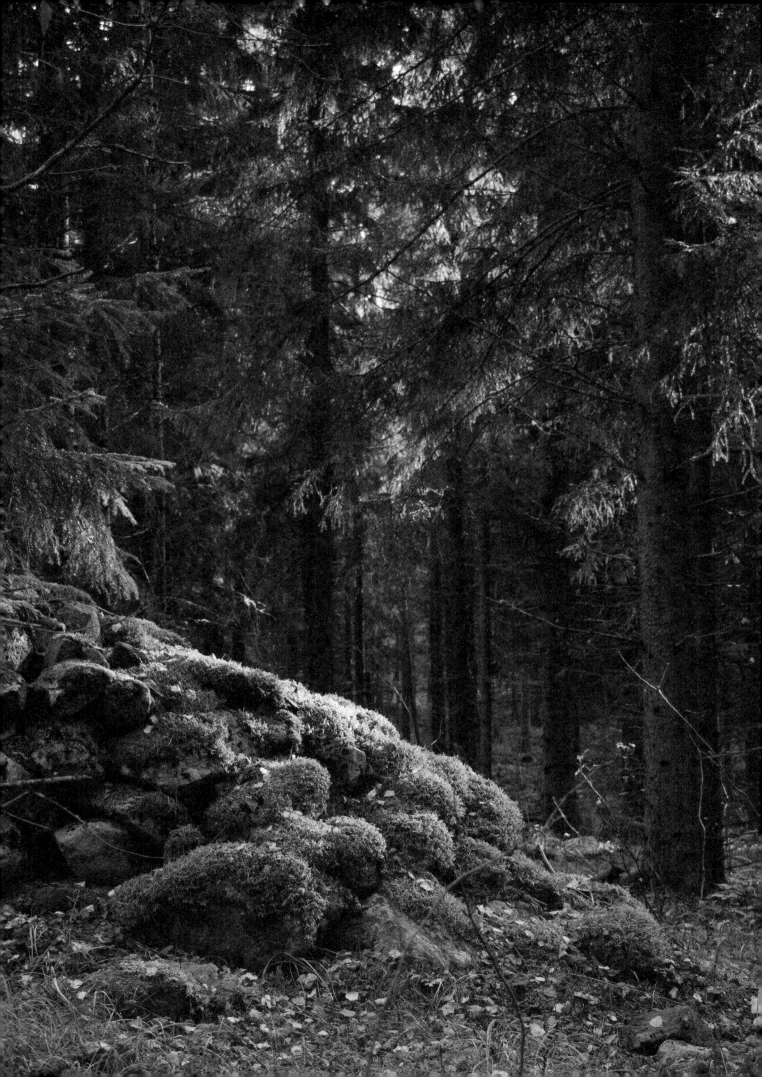

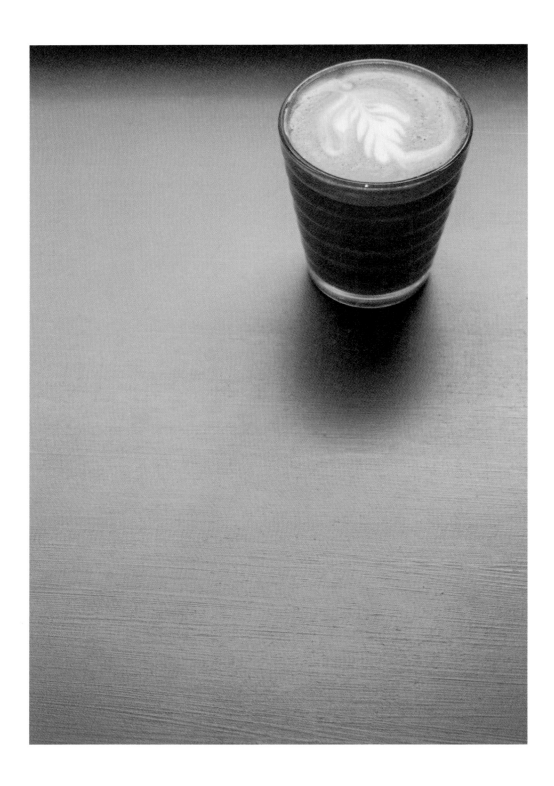

Reducing sensory input allows more time for nuance to be experienced and quality to be enjoyed.

Home is
where
the fika is

"The exposed wood reminds me of home, where much of the land is made up of forest."

"Moving to the UK in 2007 made me reflect upon Scandinavia in an entirely new way, and perhaps appreciate everything about my home region much more. I started a blog revolving around our expat life in the UK. But it would soon transpire into the opposite…"

Blogger Bianca Wessel offers insight into how "Little Scandinavian" was born. The turning point coincided with her very first visit into Nordic Bakery. "I'd heard about Nordic Bakery through friends and on a sunny autumn day in 2008, I found myself in Regent Street with an hour to spare. I'd left visitors who wanted to go shopping and headed for Golden Square. Walking through the little park with the leaves turning golden, I spotted a very Scandinavian looking shop front; as minimal as it gets.

"I remember being surprised by the interior, having to remind myself that not all Scandinavian interiors had to be white. Instead the muted interior was, as it is today: wood panelled, walls painted dark blue and simple black tables and chairs. The star attraction of the place was the large food counter and baskets filled with the cinnamon buns I had heard my friends rave about."

"I ordered black coffee and a cinnamon bun. For the next hour I enjoyed sipping my coffee slowly and tucking into the deliciously sticky cinnamon bun whilst doing nothing but looking out of the large window onto the square and watching people pass by."

"And for this exact reason I find myself needing a Nordic Bakery visit once in a while: a moment to enjoy a well-made coffee and cake (fika as we say)."

"There's something about the calming silence and the smell of freshly baked goods that I find so reassuring. The exposed wood reminds me of home, where much of the land is forest. It's that little piece of tranquility, alongside honest food that makes Nordic Bakery a special place you'd like to visit again and again."

Filter coffee
Latte
Short latte
Cappuccino
Mocha
Espresso
Extra shot

Tea
Hot chocolate

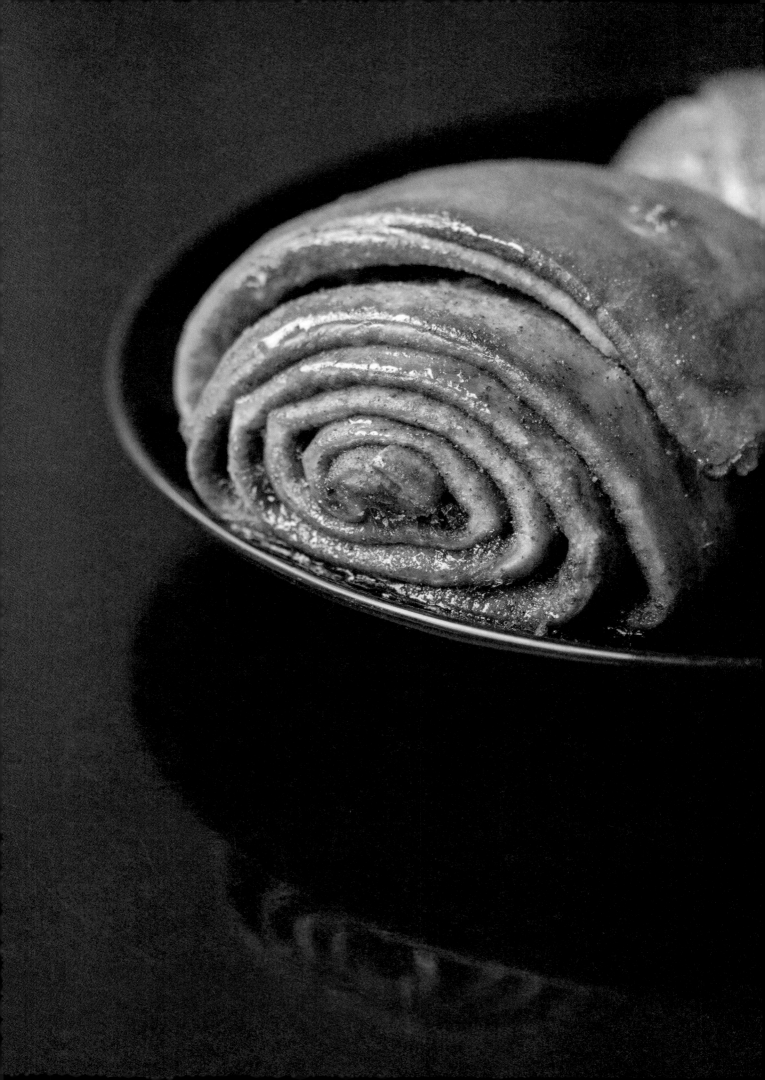

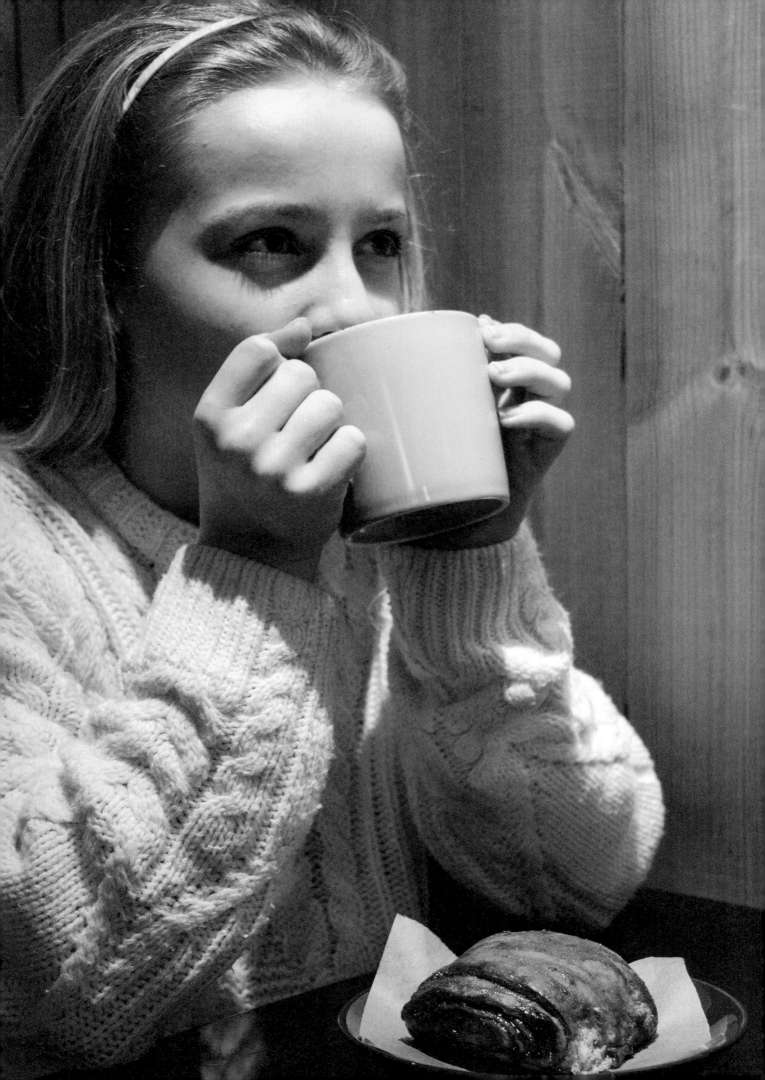

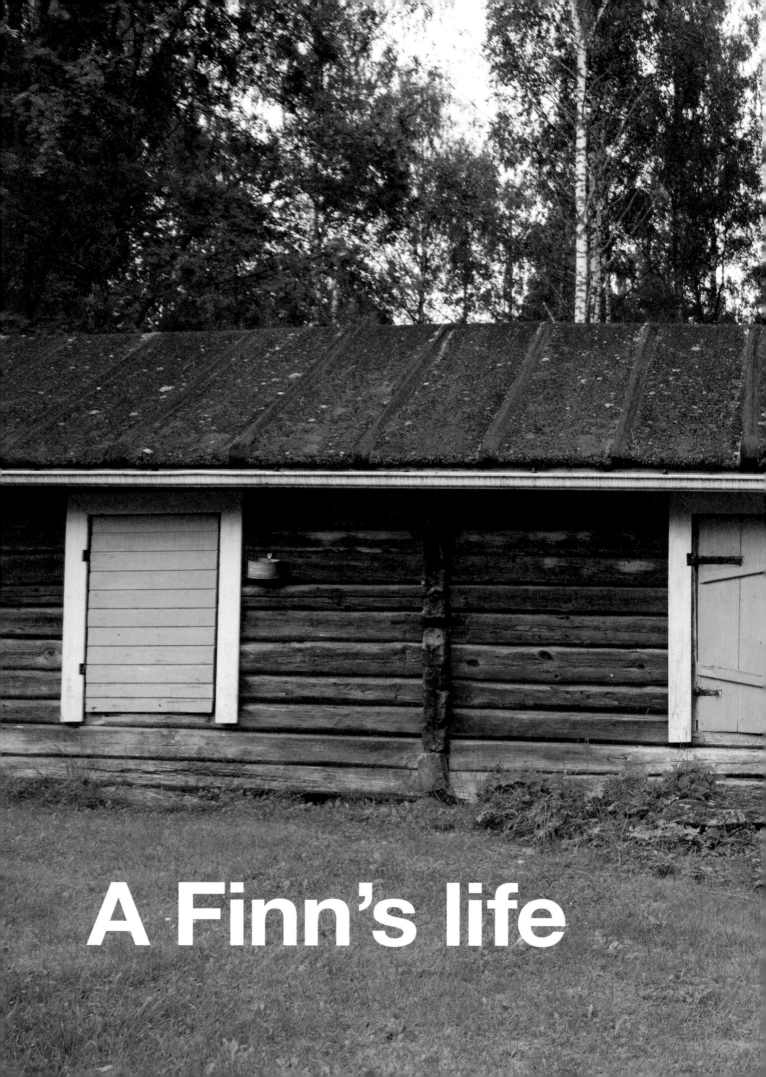

A Finn's life

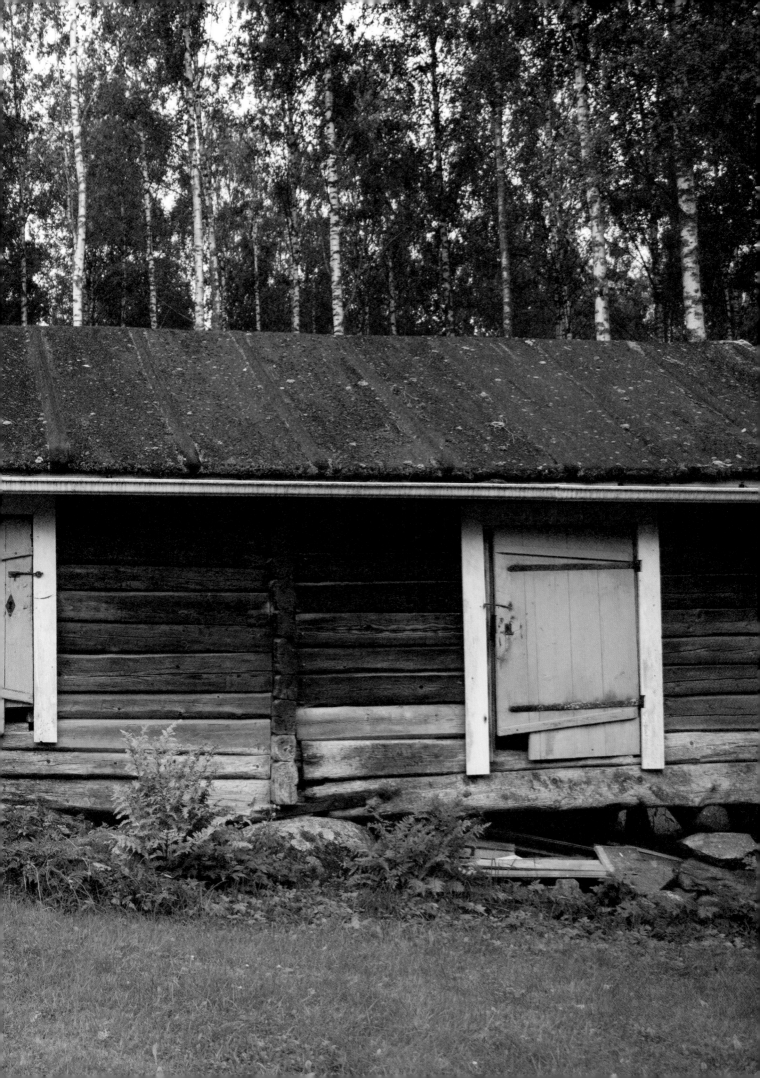

I grew up in a small town just outside of Finland's capital, Helsinki, born into a normal middle class family.

My family's roots are based in Savo, the lake district of Finland where we now spend our summer holidays in an old farmhouse on a lake, the same house where my dad grew up. We are a long ancestry of farmers and the property has been in our family for centuries.

I retain happy memories spent from all my childhood summers spent here, where life revolved around family, surrounded by all my aunts, uncles and cousins. I can recall my grandmother using a very long spoon in which to place and fetch the bread from the deep log fired oven. During our extended stays at the farmhouse, we'd enjoy the clear crystal lake; fishing, letting our toes sink into natural sand beaches and play in the surrounding forest. After we'd foraged mushrooms and berries, we'd then have a barbecue on the open fire.

Nowadays the main house is where I spend every summer with my husband, our twin sons, my parents along with my brother's family. Lots of friends come to visit and it remains a central point to our cherished Finland summers.

London is my home though. I feel at ease in the big city and energised by its constantly shifting vibe. I love the new ideas and concepts London life inspires. I feel as equally relaxed in Golden Square as I do on that lakefront in Finland.

It's London where I can merge into the urban landscape, where I can disappear. And when I do, I create my quiet moment of solitude in the middle of all the hustle and bustle.

I'm very proud of Nordic Bakery and how we can offer this little nook of tranquility in the heart of London. It is an apt glimpse of my roots nestled deeply in the Finnish forest.

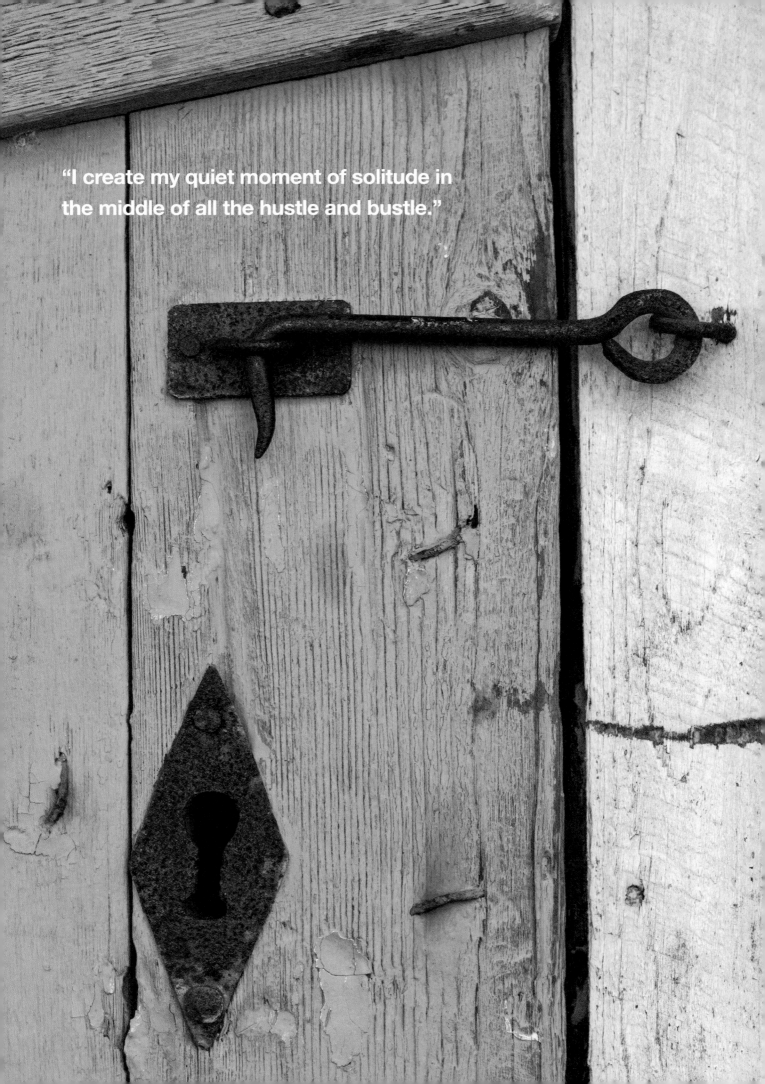

"I create my quiet moment of solitude in the middle of all the hustle and bustle."

Written in the wood

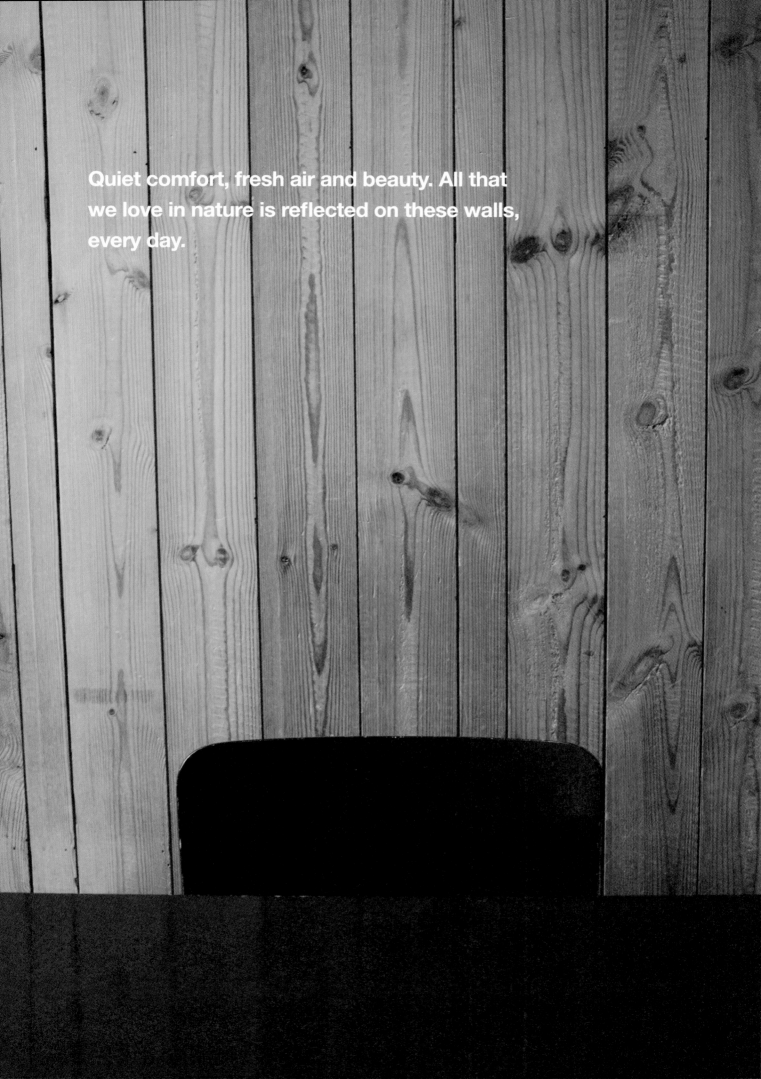

Quiet comfort, fresh air and beauty. All that
we love in nature is reflected on these walls,
every day.

Whichever Nordic Bakery you patronise, the presence of wood will soon catch your eye. So symbolic of what we most cherish about the Nordic region, this versatile material not only adorns our walls, but also acts as a positive reminder of all that we love and admire in Nordic nature. We Finns love and respect our forests, which are plentiful and cover more than 65% of the country's land. We cherish them for their generous bounty. Tastes that not only amuse the human palette but also provide real sustenance to the many types of fauna that call the forest their home.

Beyond its iconic representation of nature, the forest also stands for freedom. It is the born right of every citizen to walk where they please in Finland, to journey and discover the many uncharted paths in and of the forest. Such import is placed on this freedom to commune with nature that no land owner permit is required.

And what of quietness? The sound of silence is the soundtrack of the forest, the same one which we like to play for our patrons, as a temper to the vibrant life and busy city thoroughfares. When in nature, that quietness often inspires a supreme comfort, offering a true communion with what makes this planet so exponentially exquisite and worth protecting vehemently. Quiet, comfort, fresh air, beauty. All that we love in nature is reflected on these walls everyday. Even when no one's looking.

The wood we feature in Nordic Bakery is pine. Chosen for its exceptional durability and strength. A slow growing tree, one can look with wonder when in a forest of Finnish pines, so straight they grow and ever so orderly, like a congregation seated in the house of Mother Nature herself.

And we like our wood because it exudes warmth and a cozy glow throughout the year. A striking counterpoint on especially rainy London days.

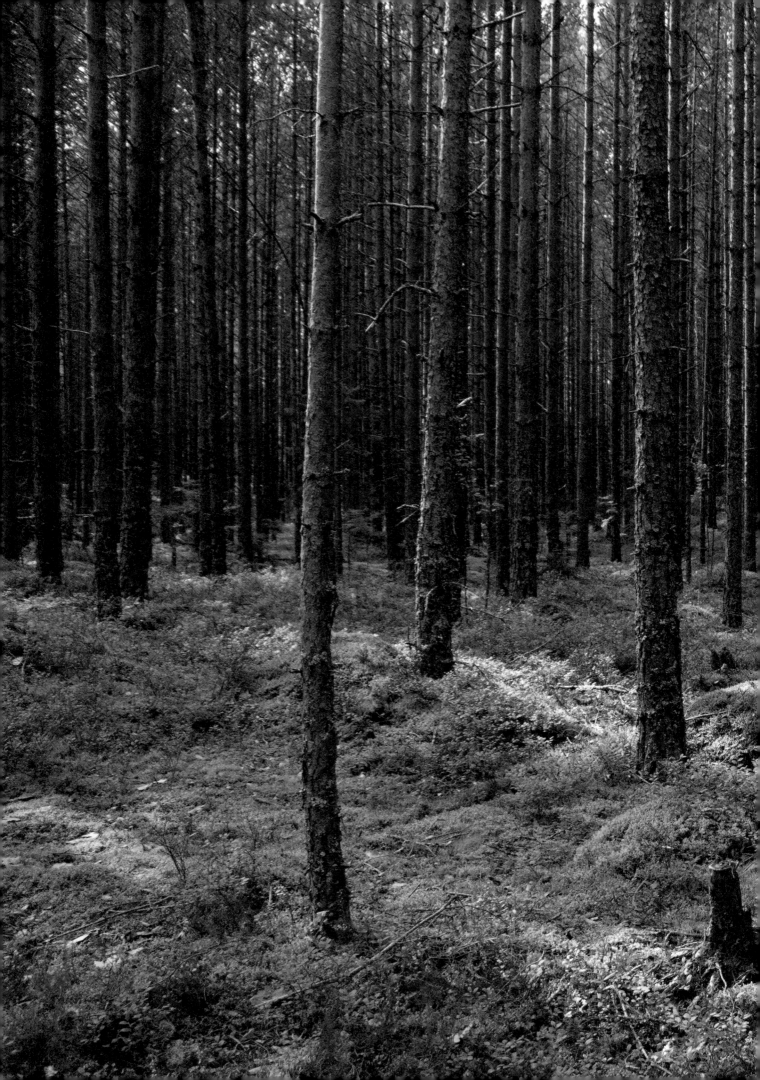

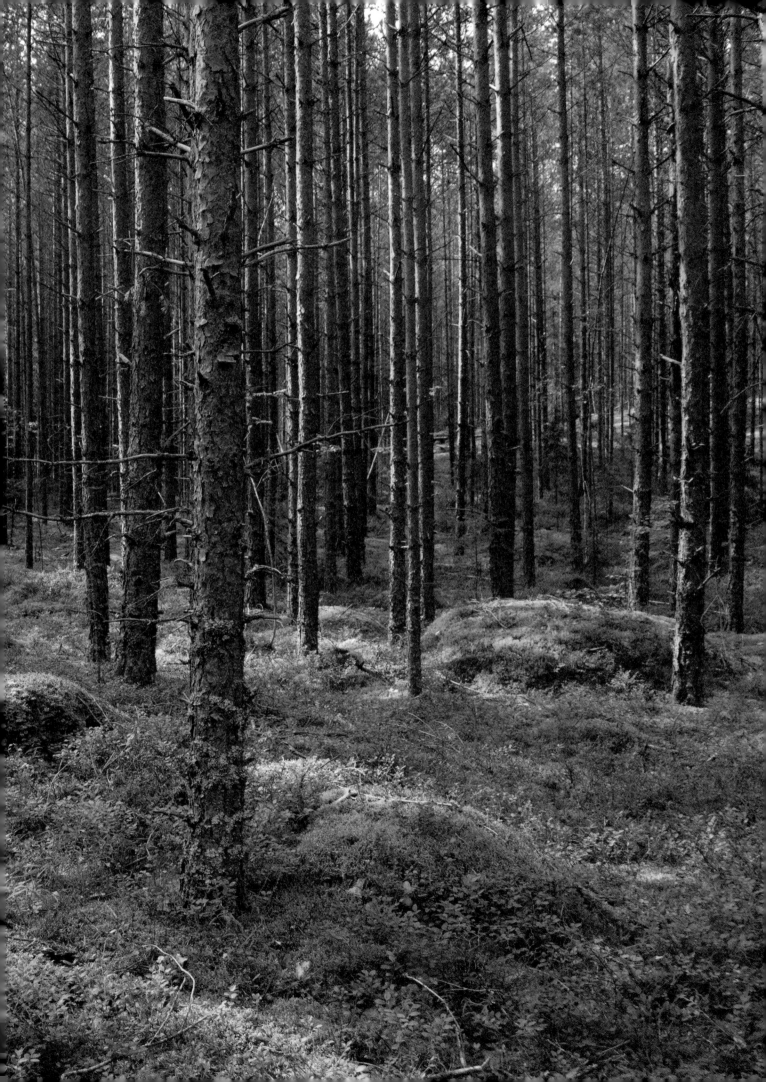

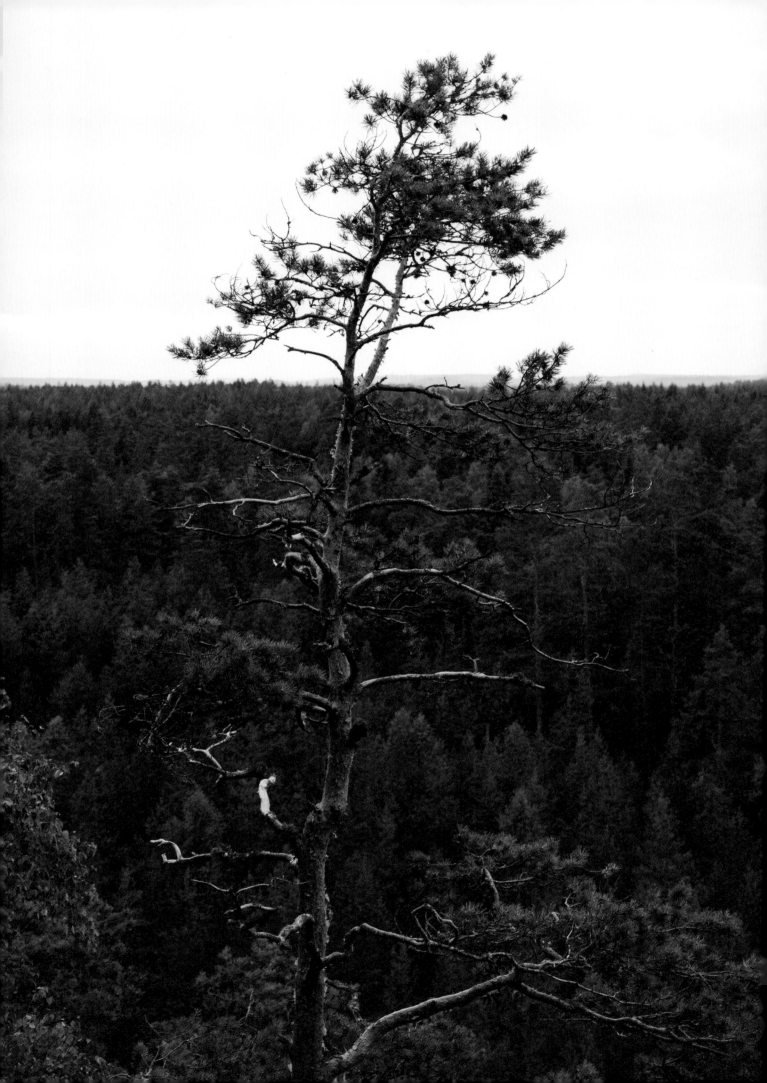

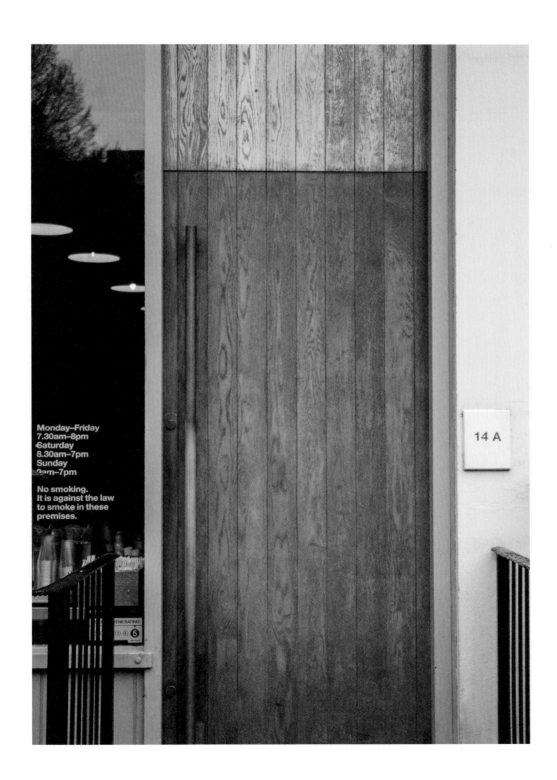

Monday–Friday
7.30am–8pm
Saturday
8.30am–7pm
Sunday
9am–7pm

No smoking.
It is against the law
to smoke in these
premises.

14 A

Every cup of Nordic Bakery coffee is thoughtfully made, whether it's filtered in traditional Nordic style or via steam preparation for every latte, cappuccino and velvety dark espresso.

Less choice makes better coffee

Before you walk into Nordic Bakery, we have already made a series of choices for you so you do not have to. We seek out, source and serve what we consider to be the most select ingredients, thereby giving you the luxury of enjoying them without being forced to choose from a myriad of options. There is no finer example of this than every cup of coffee we serve. We choose what we consider to be the best tasting beans and serve them in a single and precise serving size so that you can focus solely on its beneficial properties. The average adult makes up to 35,000 decisions per day. Our mission is to offer a moment of stillness in both body and mind by providing you with an outstanding experience. By removing a series of decisions devoted to cup size, and other minor variations, we offer you more time for restoration.

Coffee is the perfect accompaniment for the many occasions celebrated here at Nordic Bakery on a daily basis. It adds increased warmth and depth to our baked goods, invigorates the mind and senses, and is palette-perfect shared with good company, or simply in the company of one's own thoughts.

Every cup of Nordic Bakery coffee is thoughtfully made, whether it is filtered in traditional Nordic style or via steam preparation for every latte, cappuccino and velvety dark espresso. As the coffee grinds bloom with the very first pour, the aroma slowly builds in strength and becomes a permanent sensory fixture throughout the Nordic Bakery day. We always offer our coffee in our signature cup and saucer, and it arrives to you at your seat by one of our aproned staff on a perfectly proportioned tray.

Our daily acts of love and devotion.

Every detail adds to the whole.

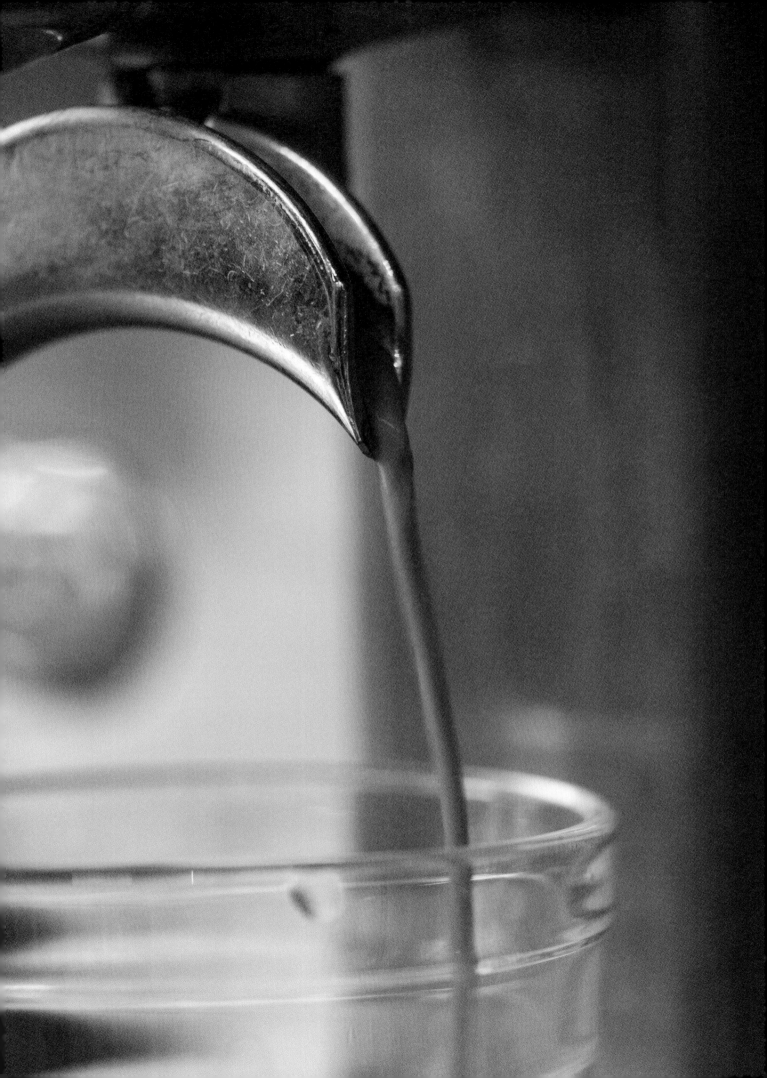

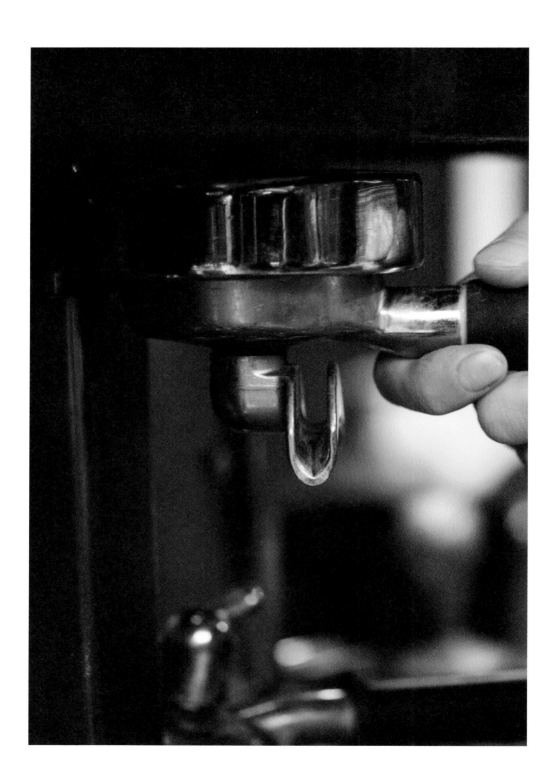

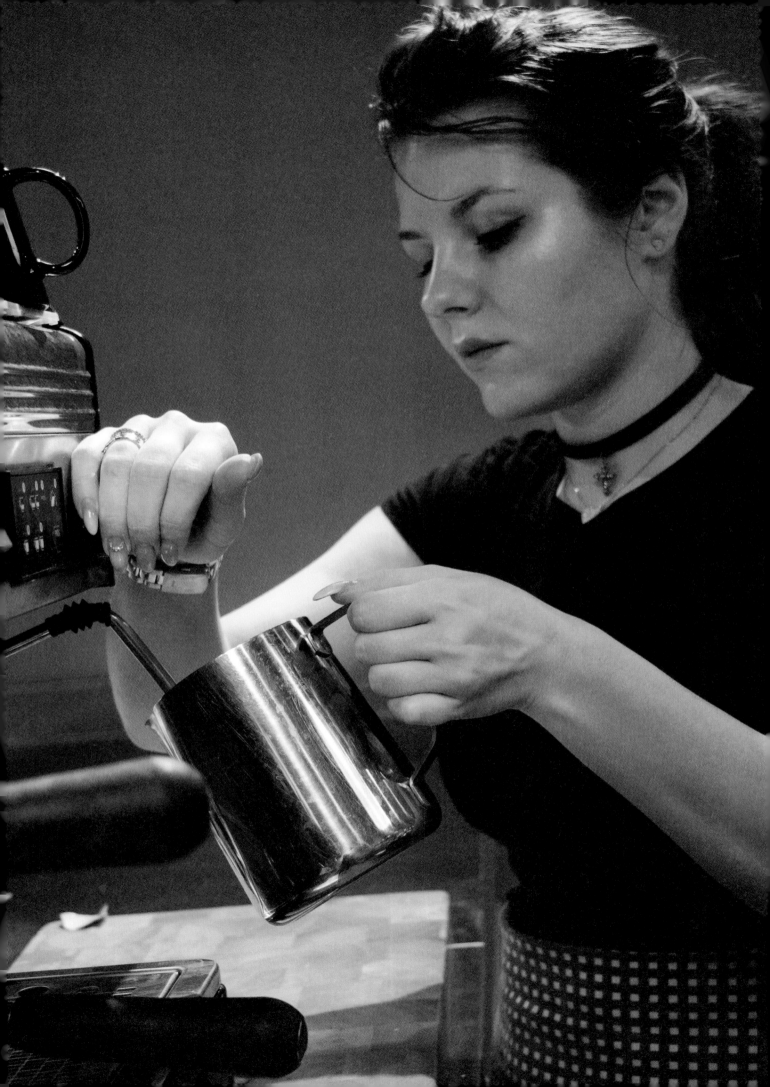

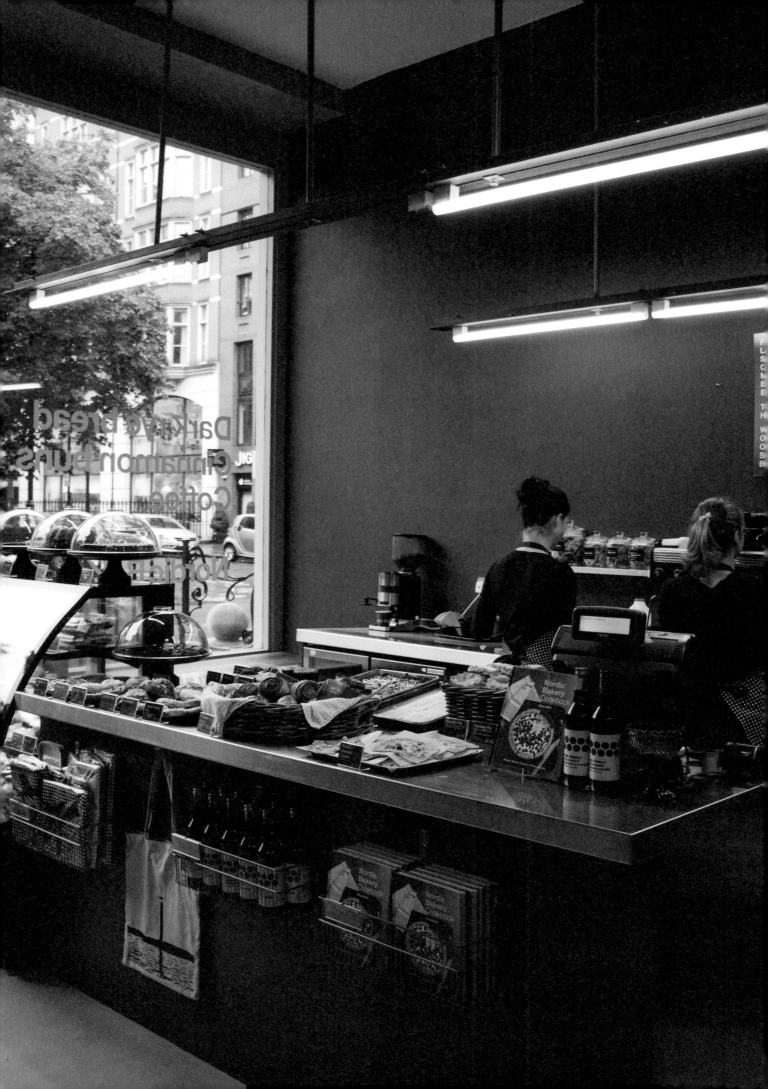

Timeless
design
one sip
at a time

With a continual focus on providing a total experience for our customers, we choose with care the tableware we present our beverages in and food upon. Specifically selected to reflect our roots, the choice to use pieces from Finnish design house Iittala captures perfectly the spirit of Nordic Bakery. Every Iittala piece in the carefully curated Scandinavian inspired collection is produced with thoughtful integrity and care. In fact, many of the most iconic pieces from the Iittala portfolio – including Aino Aalto glassware and Teema tableware by Kaj Franck – are pieces our patrons hold every day. That the pieces work so well together in their ability to combine past generations with the present is a testament to their thoughtful aesthetics and ability to stand the test of time. Says Iittala representative Siru Nori "Iittala design could be described as silent design; it does not shout at you, but lets you value and understand the functionality in everyday use over time."

Siru continues, "The products are also a vessel to communicate the Nordic lifestyle, where it's born and what marks its inherent characteristics: our aesthetics, our way of living. Nordic countries have a lot to offer in terms of striking a good life balance; valuing the basics in life, the connection to nature and our longing for harmony and ambiance at home through the drastically changing seasons. It's a very democratic way of looking at high quality design as a part of everyday life. Nordic Bakery does a fantastic job in being the ambassador for the Nordic lifestyle, the cuisine and the delicacies that are not as widely known as many others. For Iittala, it is the most natural and wonderful connection: to be used in a genuine context within a brand that carries the same sustainable values as we do in Iittala."

"littala design could be described as silent design; it does not shout at you, but lets you value and understand the functionality in everyday use over time."

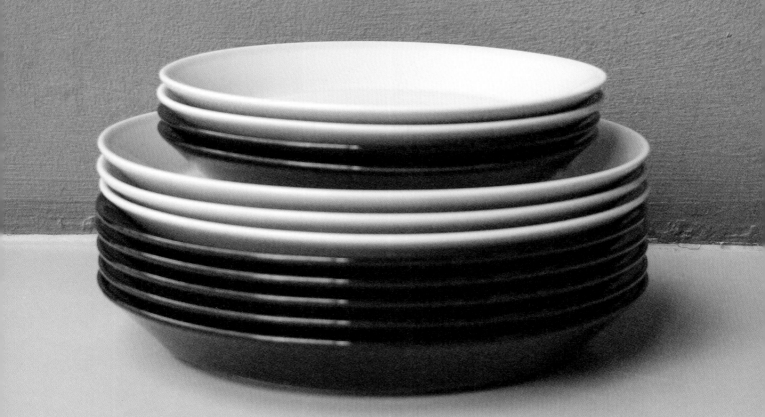

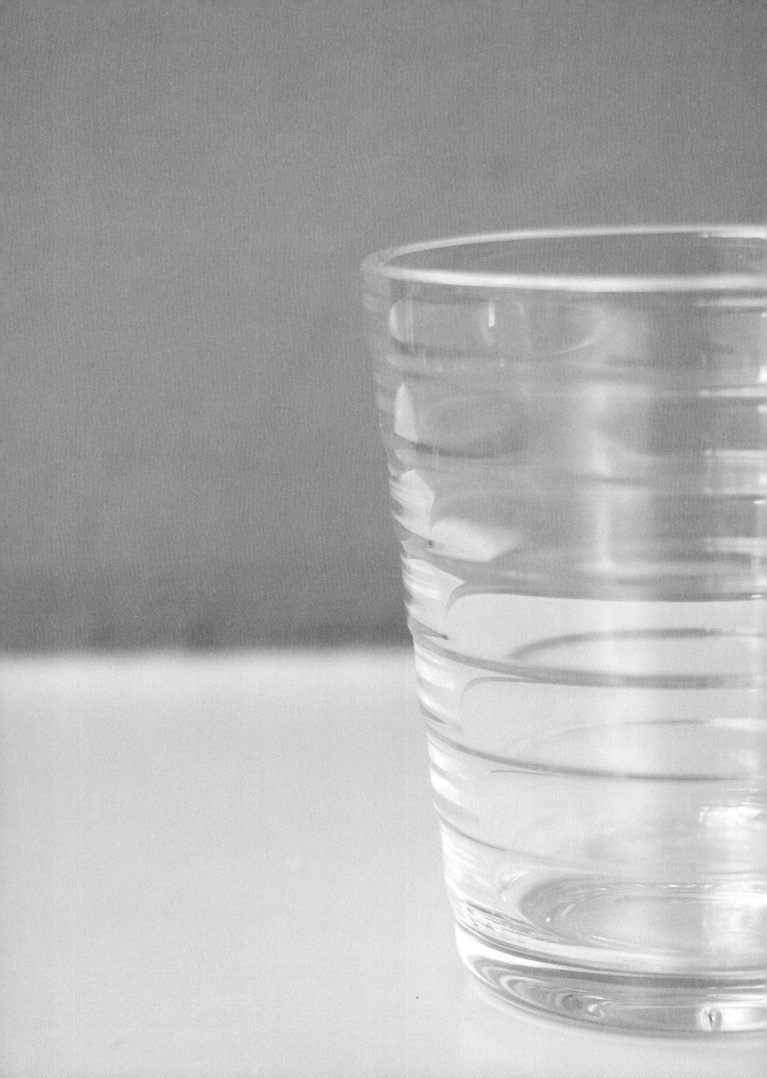

Timeless design one sip at a time

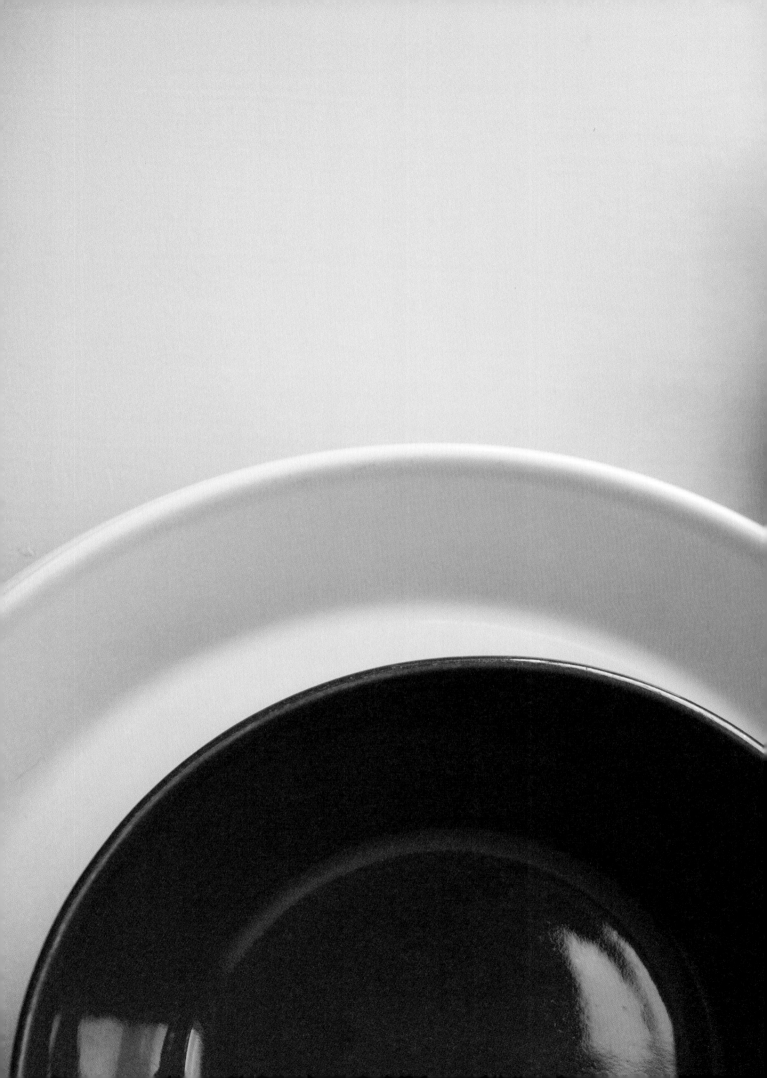

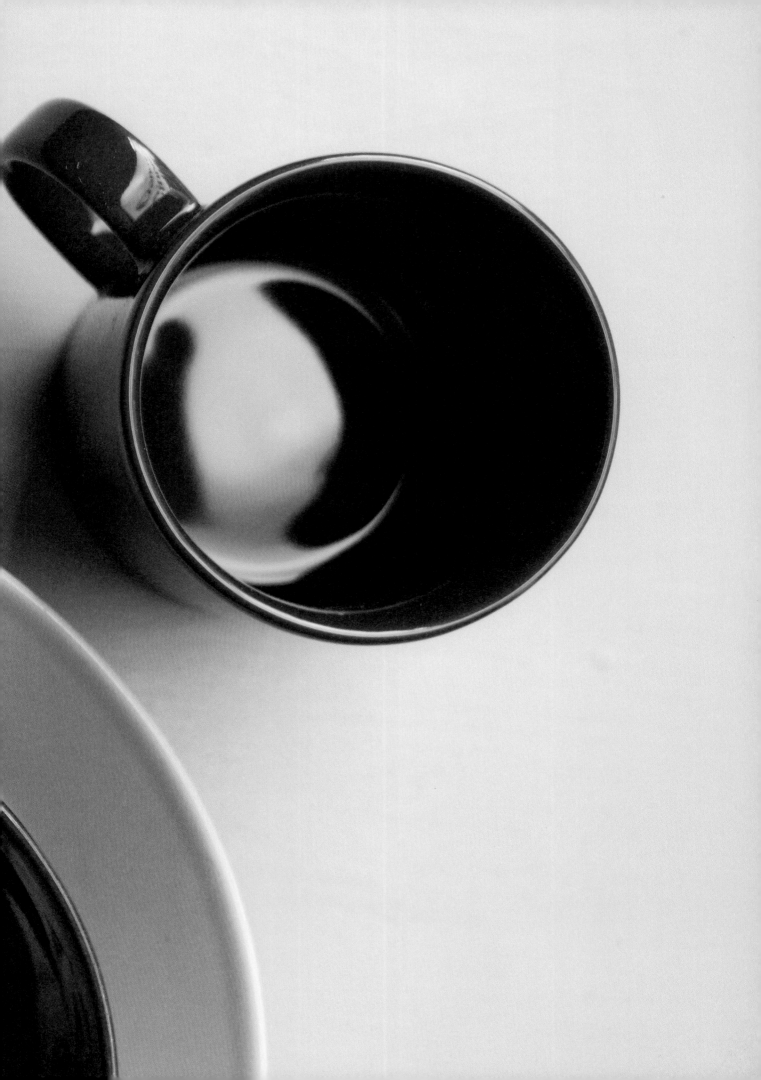

At the heart
the hearth

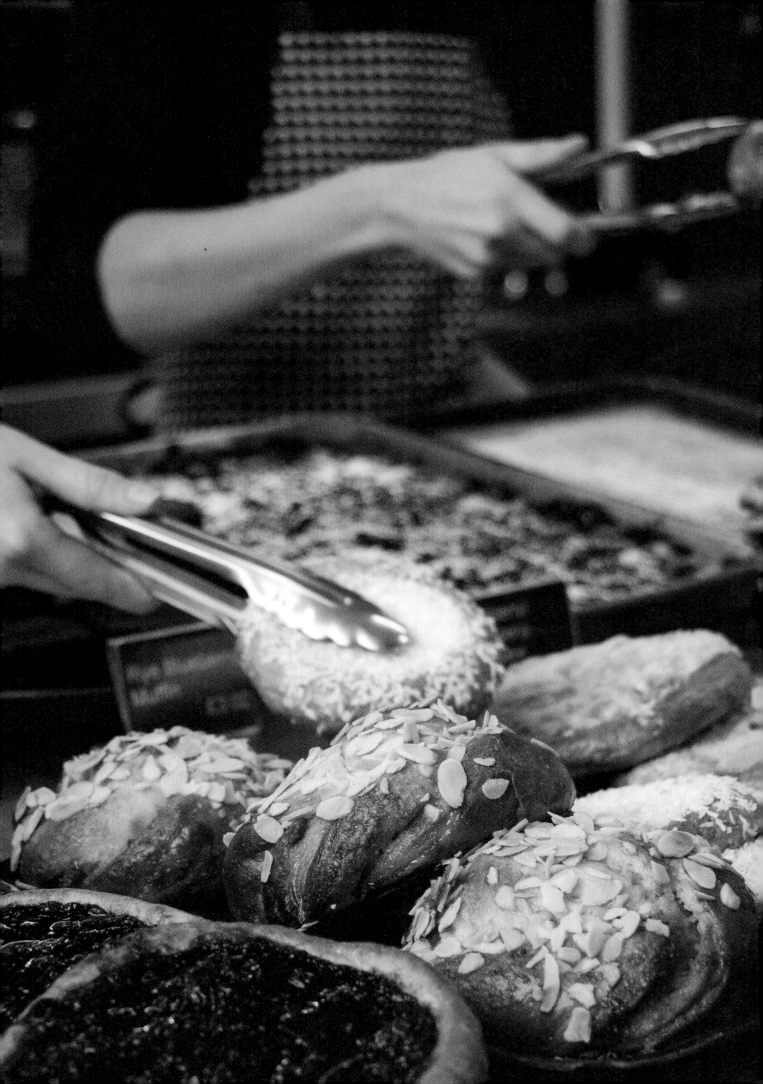

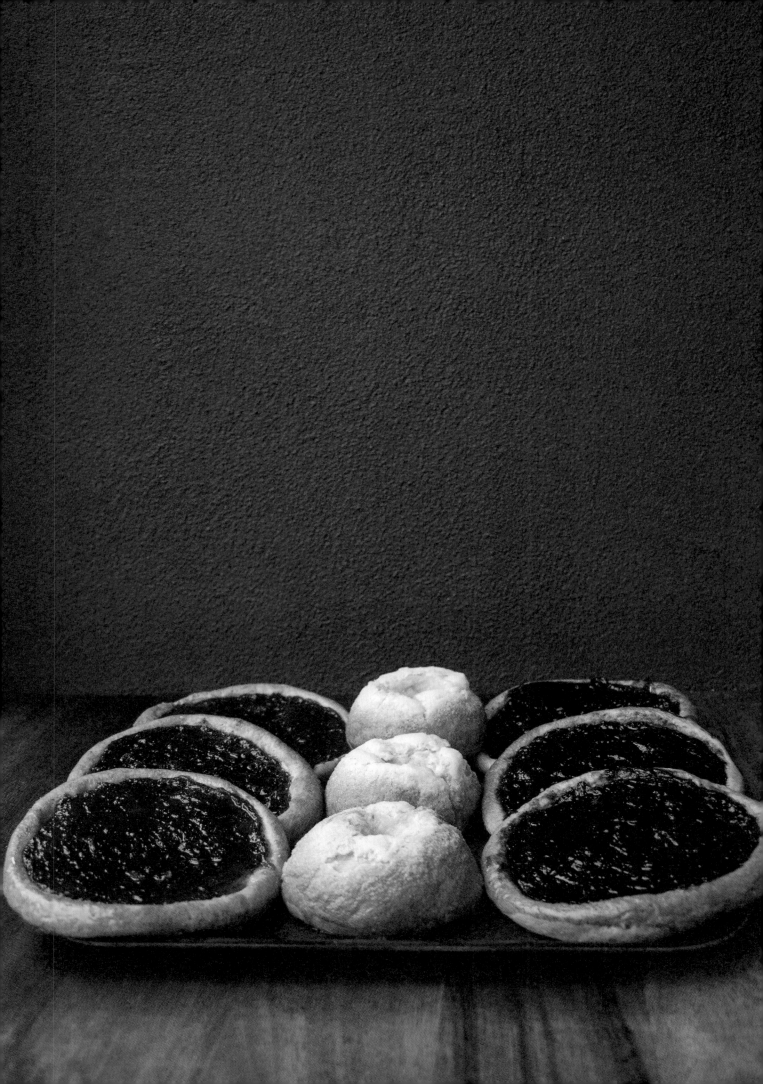

At Nordic Bakery, preparing foods from scratch is synonymous with our brand. It represents the long heritage and importance of the baking and cooking that happens in the traditional Nordic home. One where the kitchen's hearth is truly the heart of the home. It's often a family activity, a time when everyone naturally gravitates towards the kitchen; either baking together or attracted by the aromas of freshly made goods just after they're being pulled from the oven, steaming up the windows in the tray's wake from oven to table.

I bake with my kids. We make 'pulla', which are cinnamon, cardamom or simple butter buns, as well as 'sämpylä', wheat or oat rolls which are great with hearty soups or stews in the winter or summer picnics. Oat rolls with soup or stew are real 'hygge'; chilling out at home, being cosy and eating good food well into the evening.

At Christmas, our tradition is to bake pipari ginger biscuit-men and women. That goes hand in hand with the annual construction of the gingerbread house with my kids. They love it. And can't wait to eat the yard and tear down the house soon after.

For us Finns, it is a long standing tradition to make our own bread. Whatever it may be – rolls, buns and cakes, they all get assembled and baked in a big batch which are then portioned out and dropped into the deep freeze for later sustenance and enjoyment. Many Nordic people believe in being self sufficient. That means freezing mushrooms and berries in warmer months for nourishment through the colder ones. It also extends to baking. Many people, even those harnessed with busy schedules, prefer to take the time to create homemade food instead of purchasing store-bought, factory refined creations. It all comes down to enjoyment and quality of life.

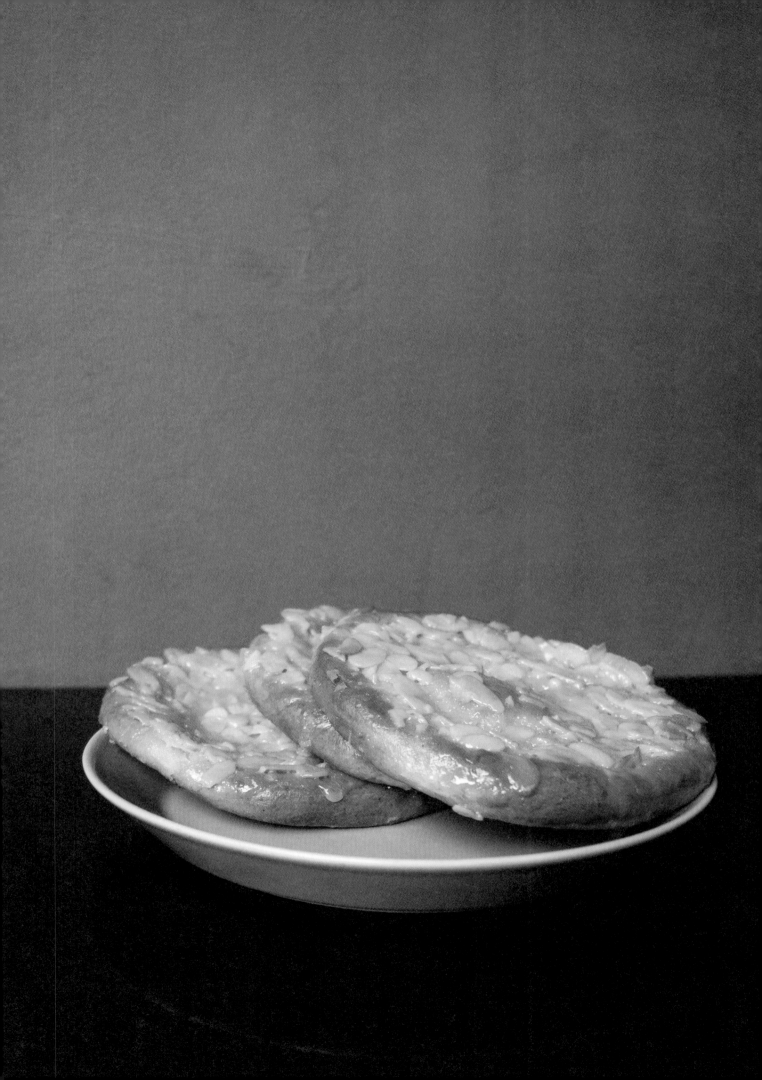

Apple Tosca Bun

Make the dough by mixing the milk, sugar, yeast, cardamom, melted butter and egg in a food processor or mixer with the dough hook. With the motor running, gradually add the flour until it is all incorporated and the dough has come together.

Transfer the dough to a bowl, cover with a clean tea towel and leave to prove in a warm place for 1 hour, or until it has doubled in size.

Shape the dough into 80-gram balls and arrange on the prepared baking trays. Press it with a round shape mould covered in flour (approx. 9 cm) to make a deep hole. Cover with the tea towels again and leave to prove in a warm place for 30 minutes.

Preheat the oven to 180 °C, 350 °F Gas 4.

To make the topping put all ingredients in a saucepan over low heat, stir to mix and bring gently to a boil.

Arrange the apple slices neatly in a pattern over the hole of each bun then spread 1–2 tablespoons of the tosca topping evenly over it.

Brush the sides with the beaten egg and bake in the preheated oven for 15 mins, or until golden brown.

Makes 12

Dough
285 ml lukewarm milk
75 g caster sugar
22 g fresh yeast (or easy blend dried yeast according to manufacturer's instructions)
½ teaspoon cardamom seeds, crushed with a pestle and mortar
90 g unsalted butter, melted
½ egg
500 g plain flour

Tosca topping
225 g unsalted butter
225 g caster sugar
75 g plain flour
225 g flaked almonds
150 ml double cream

6 sour green apples, peeled, cored and thinly sliced
1 egg, lightly beaten for glazing

1–2 baking trays, lined with non-stick baking paper

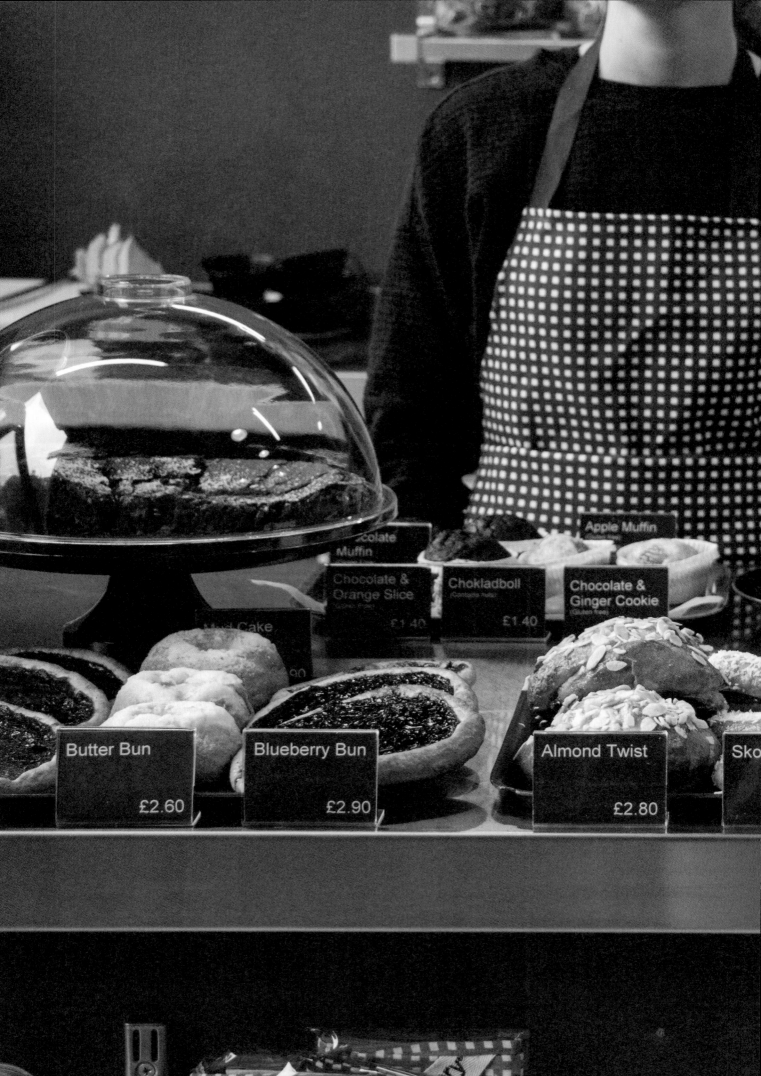

Apple Muffin

colate
Muffin

Chocolate &
Orange Slice

Chokladboll

Chocolate &
Ginger Cookie

£1.40

£1.40

Mud Cake

Butter Bun

Blueberry Bun

Almond Twist

Sko

£2.60

£2.90

£2.80

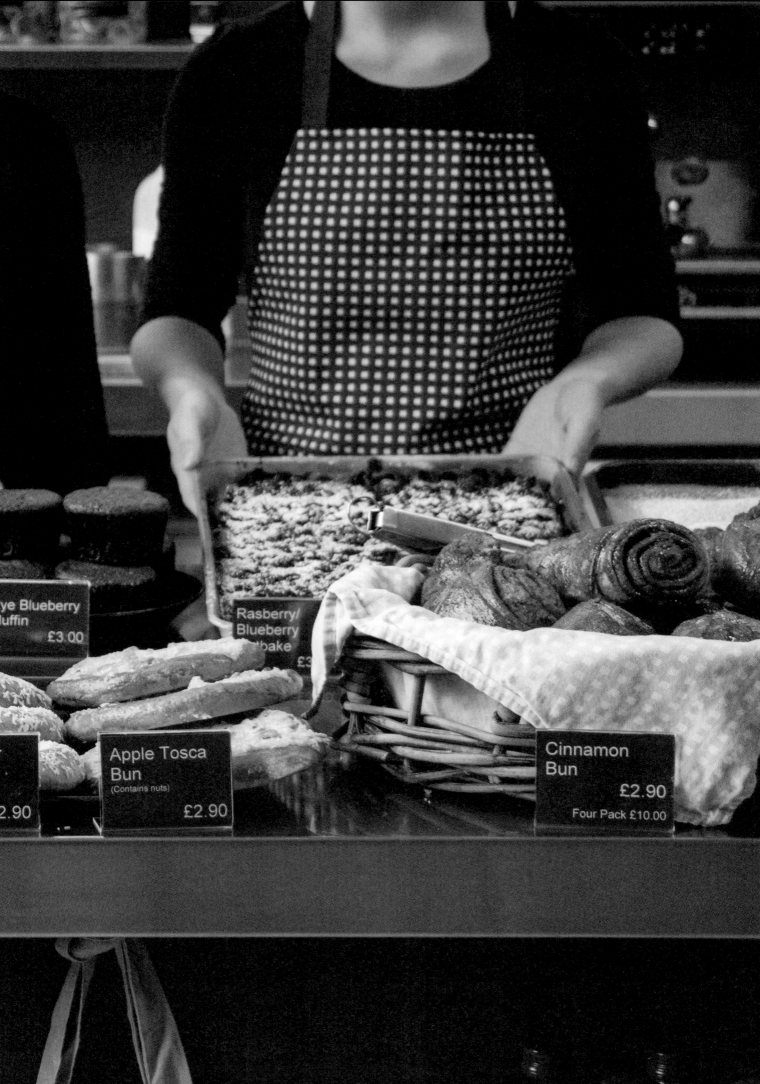

Cinnamon
bun girl

Depending on the time of day, you might find graphic designer Cindy Cheung either working quietly, her coffee cup her only companion or, with her work colleagues, brainstorming new ideas. "Nordic Bakery is a peaceful escape from the hustle and bustle of the urban city and it also acts as a 'Social Hub' for myself and my work colleagues. There's no better way to celebrate a completed big project than with two of my favourite things: Coffee and cakes."

As a self-described food enthusiast, Nordic Bakery fulfils Cindy's primary passions – food, and design. Describing the space itself she says, "It feels timeless. It's a very tasteful setting with high ceilings and a minimalist interior. As a brand, Nordic Bakery doesn't try too hard but it's still able to connect with me. I feel content when I sit here because I can relate with their philosophy. You also feel it reflected in their brand communications and social channels. They are always working to improve the way we enjoy our everyday lives by spreading positivity and paying attention to the little details."

"From the authentic design pieces used to serve their food and drinks, and the use of the Helvetica font in print material (being a graphic designer, you appreciate these details), to the choice of tableware and furnishings – these fusions form a very aesthetically pleasing brand and venue."

"Being Chinese, sharing food is an important social aspect of culture. My parents and I are very into Chinese cuisine, especially eating it, and we are all about sharing good food and drink and connecting with others. Nordic Bakery is a place I like to take my team to, or buy boxes of buns from as office treats, especially when we have completed a successful project. Their cinnamon buns are massive. Sharing a bun with good friends or colleagues is a form of bonding with others.

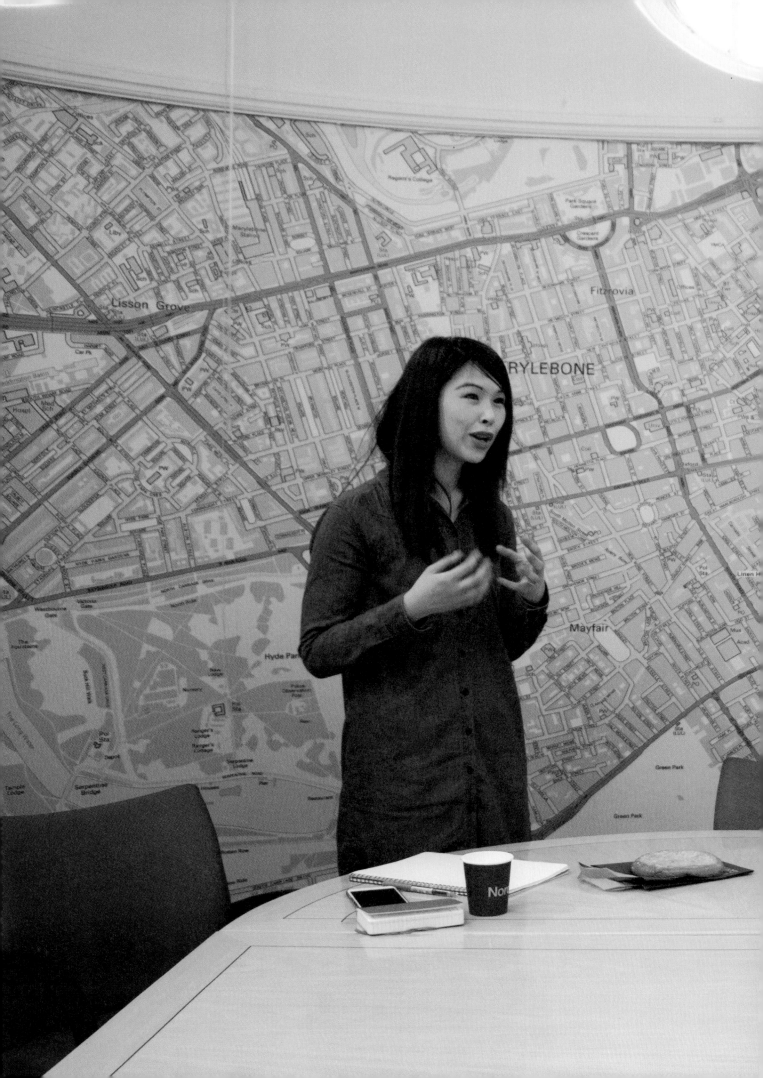

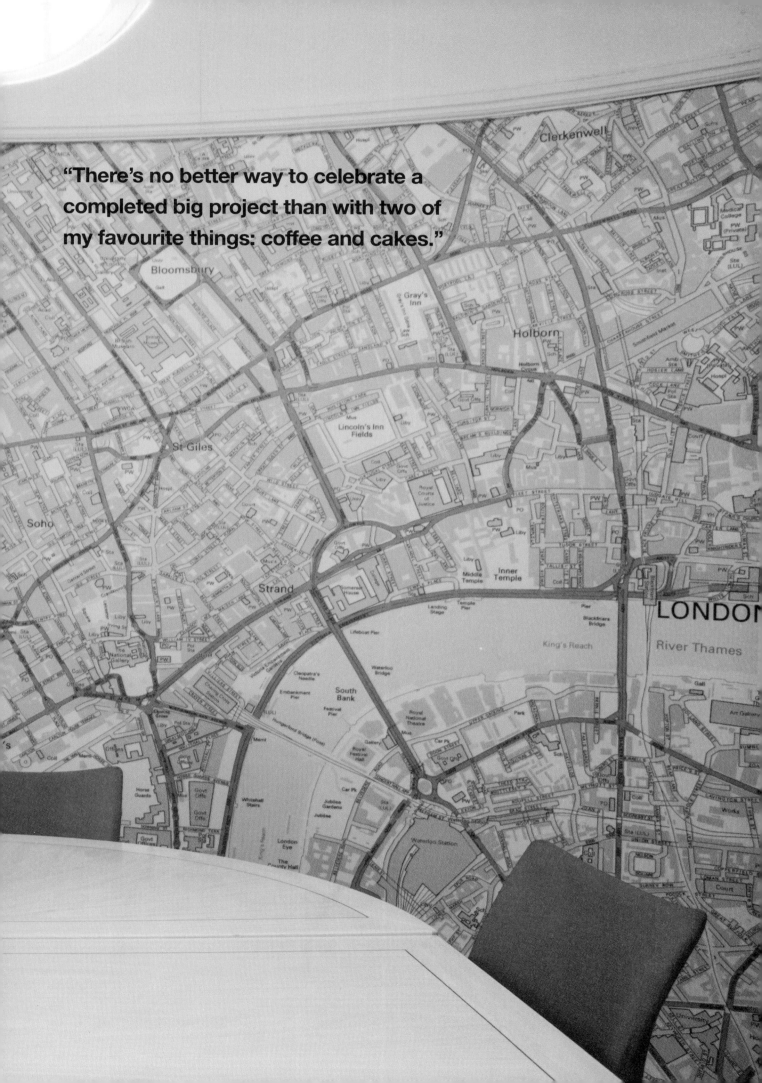

"There's no better way to celebrate a completed big project than with two of my favourite things: coffee and cakes."

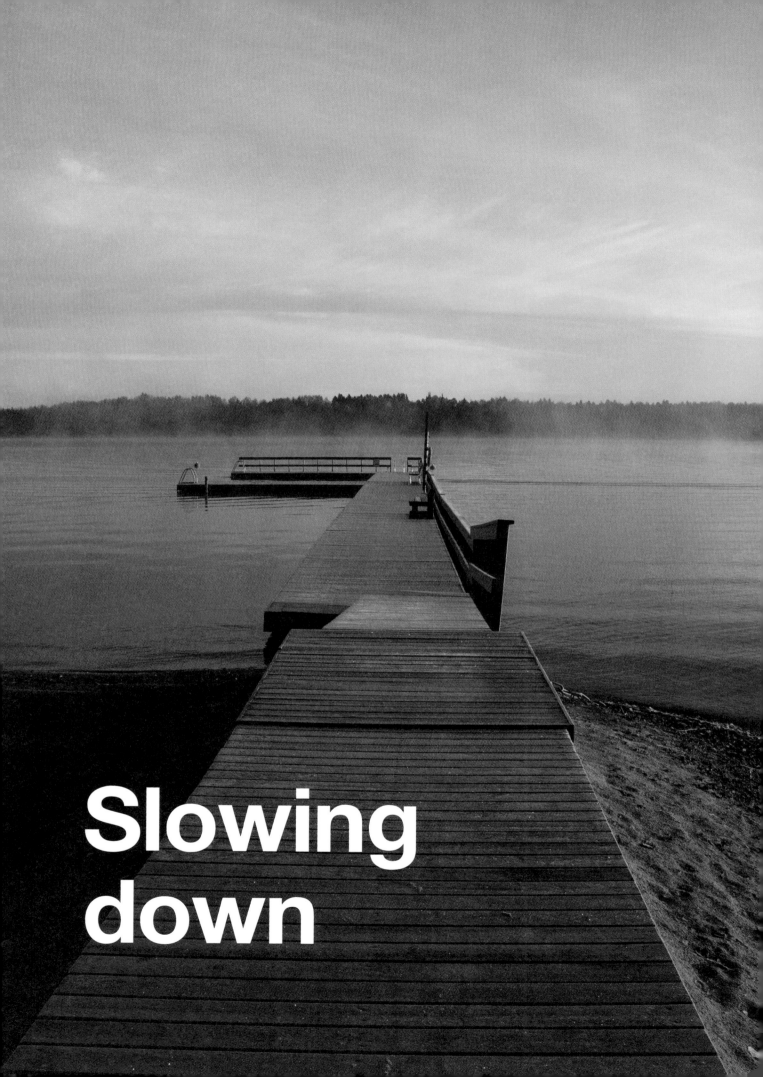

Slowing down

In this book we have aimed to share with you our daily practices in offering you a place to gently hit the 'reset' button in the midst of living busied London lives. Practices which are inspired by our own Nordic traditions. We hope to offer you hints at how you can incorporate what we have found to be tried and true elements that can resonate easily into your own daily lifestyle. Living mindfully extends beyond the yoga or massage studio. We believe that to live mindfully merits our whole attention with our whole body, as often as possible, each day. From the moment we wake up, and especially to those in-between moments when we dart from one place to the next, living mindfully can be that extra piece in the puzzle we all need to locate. It's about taking those moments throughout the day, and not just when we return back to our urban nests.

And how do we do that? As said in the beginning – through beauty and silence. Slowing down. Beauty is abundant everywhere, most especially in our fair London city. By slowing down, breathing more deeply, by looking up and around us, we are witness to simple, life astonishing, life affirming, majestic beauty.

We find that when we're more aware of what's around us, we heighten our appreciation of everyday objects – the feel of the grain off the wooden table we're seated at, the smooth warmth of the wool coat's lining protecting us, the thoughtfully weighted spoon between our fingers.

Such moments are simple, so valuable and yet so often overlooked. When we allow them into our lives, we discover simple treasures that were there all along. Small gifts of awareness to keep close, to guide and strengthen our instincts.

We hope we have been able to give you a little piece of silence and beauty through the pages of this book.

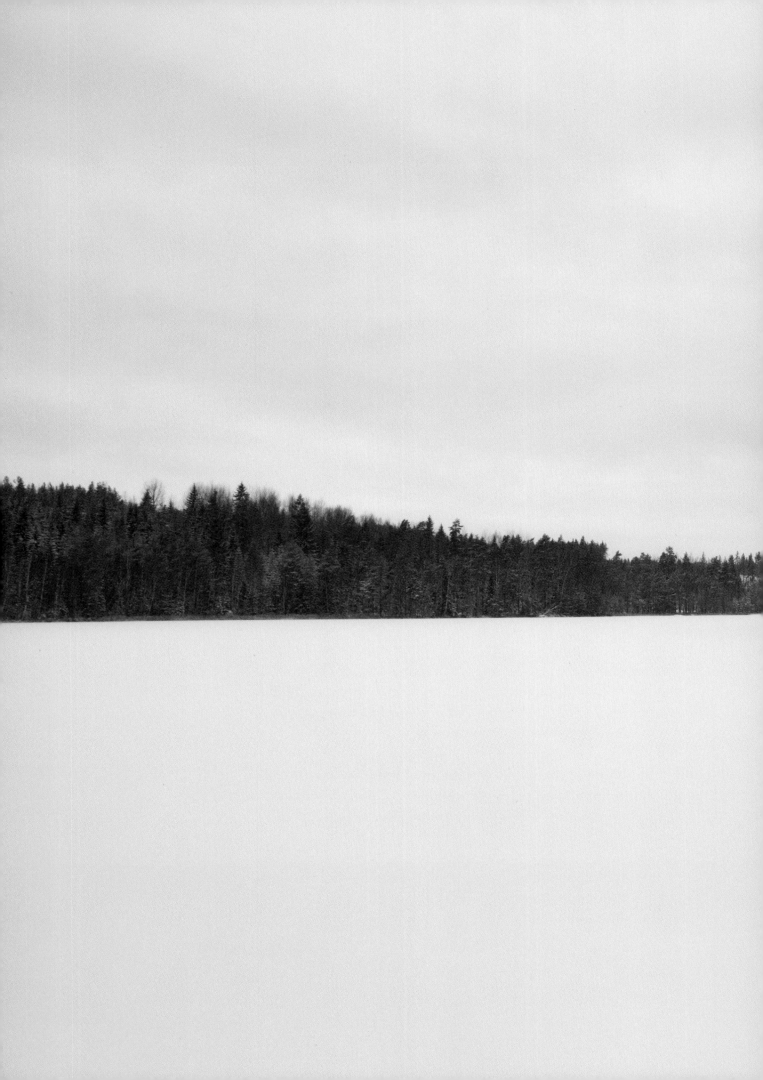

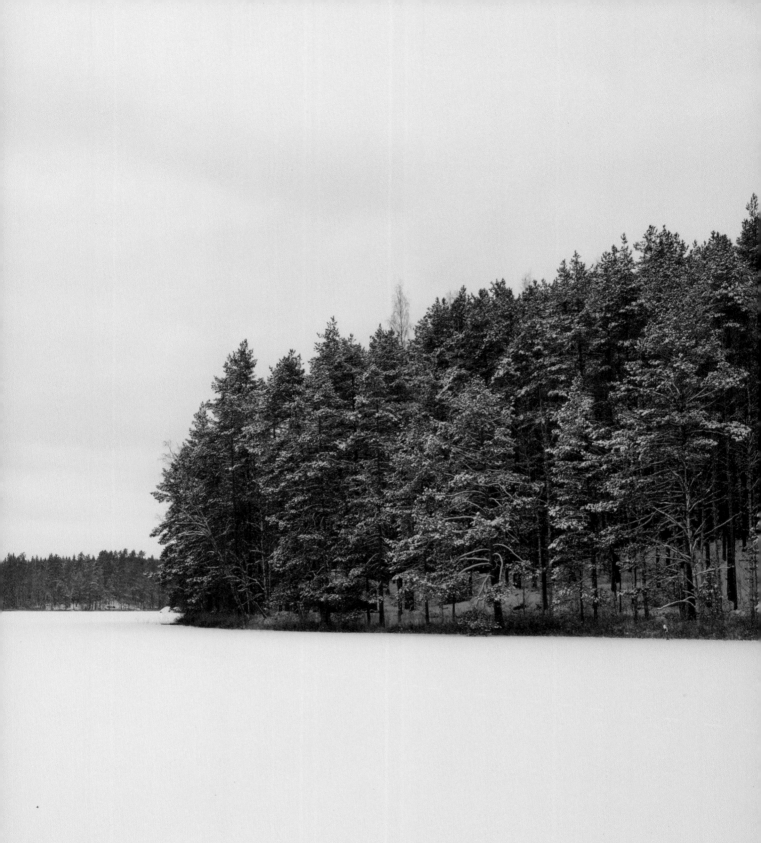

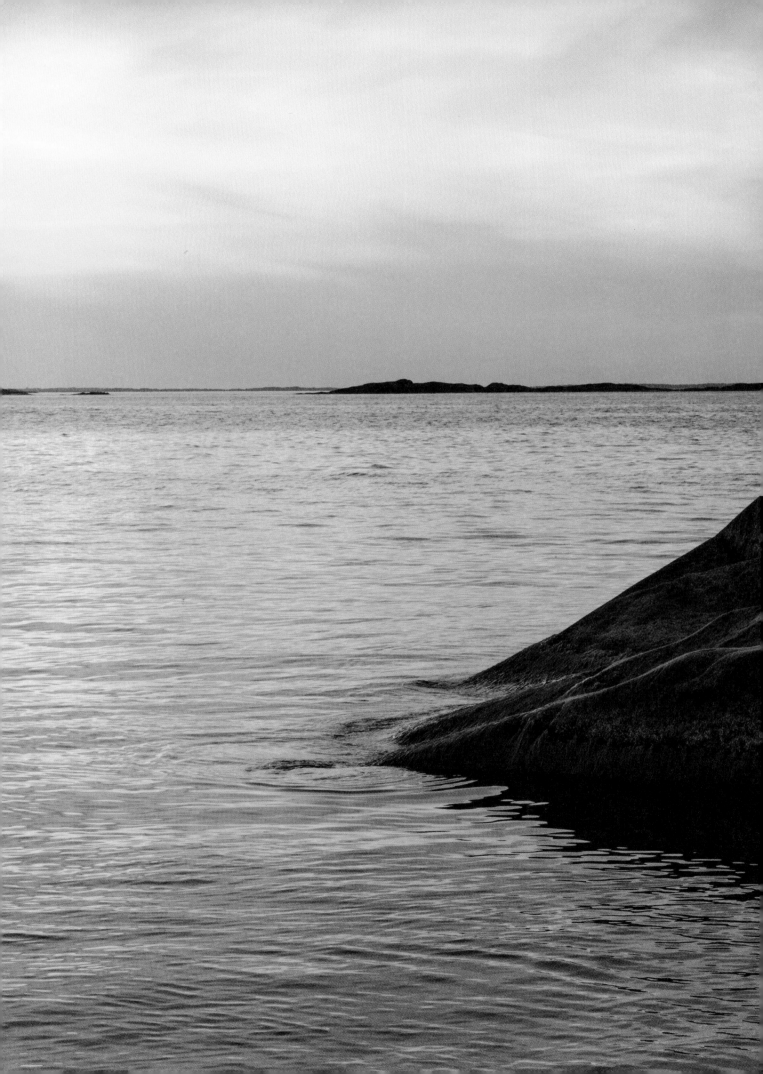

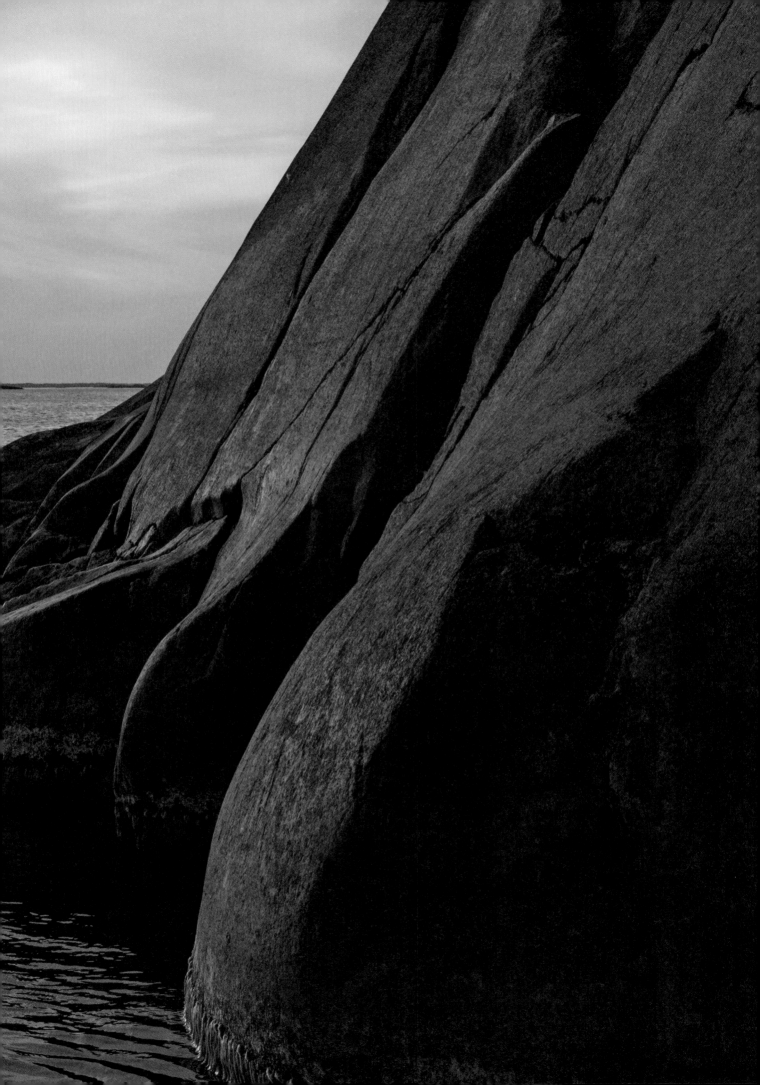

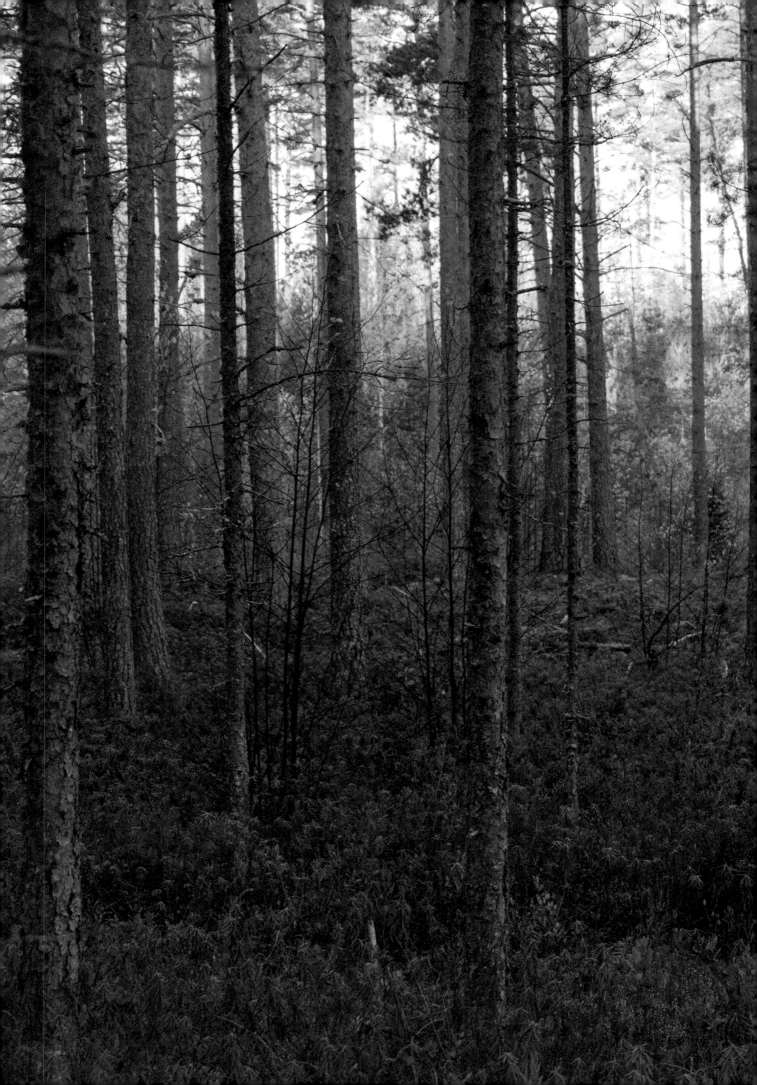

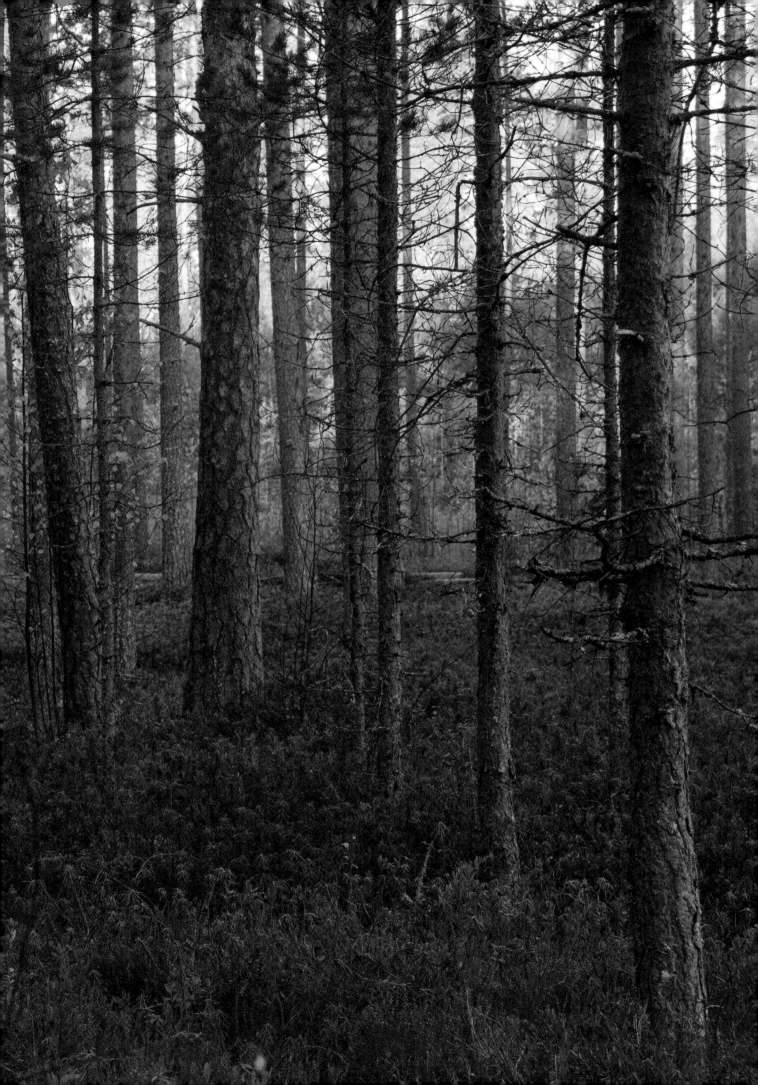

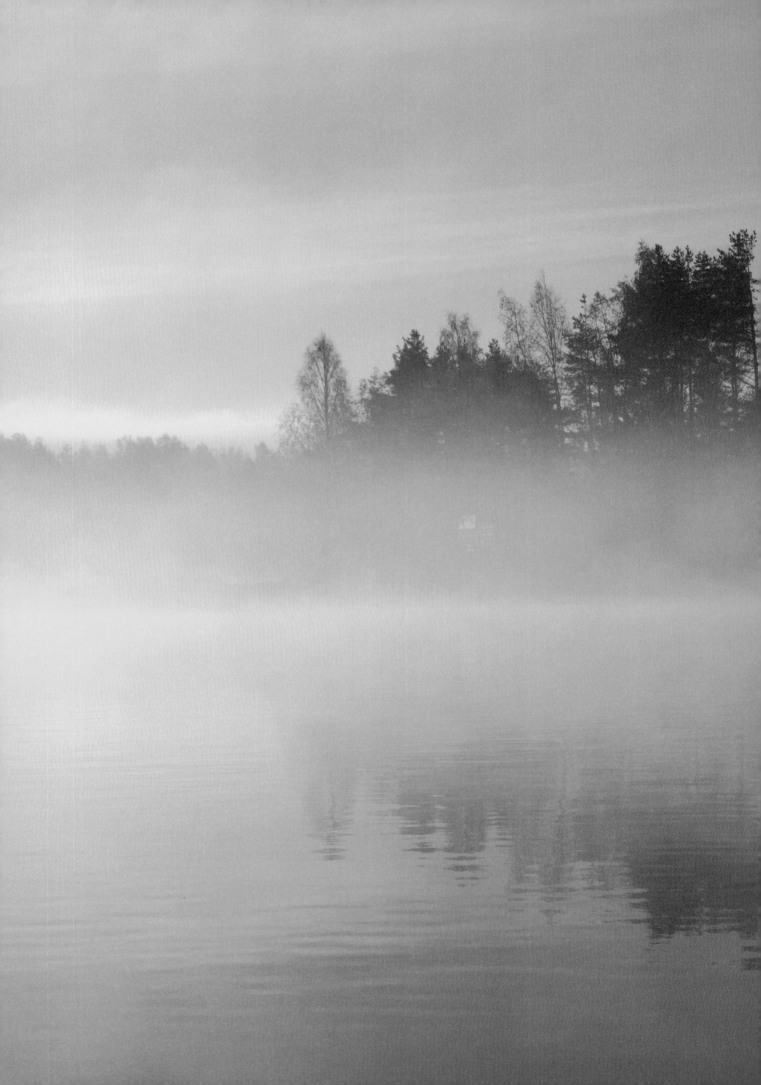

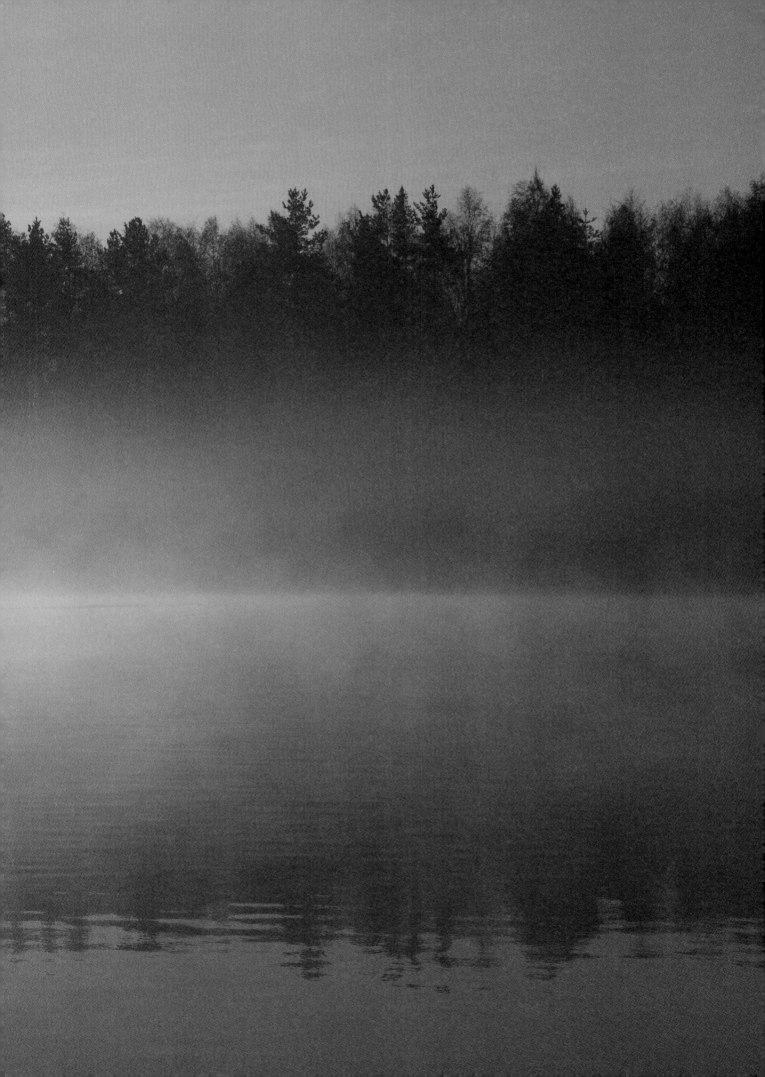

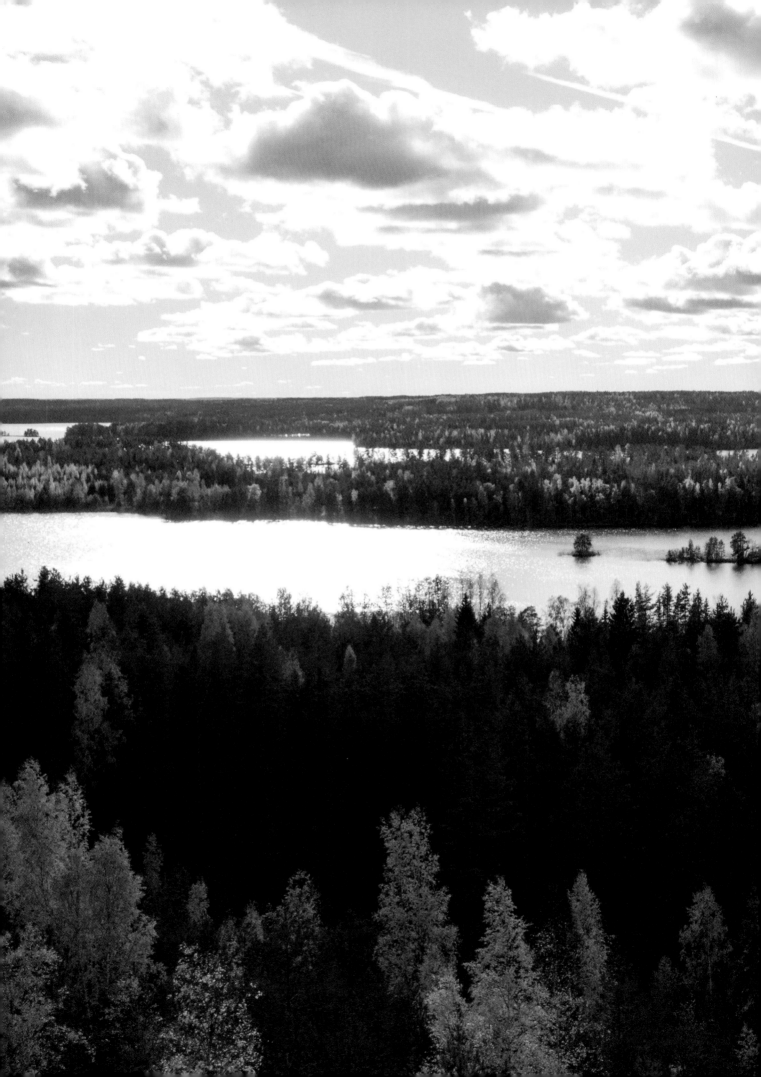

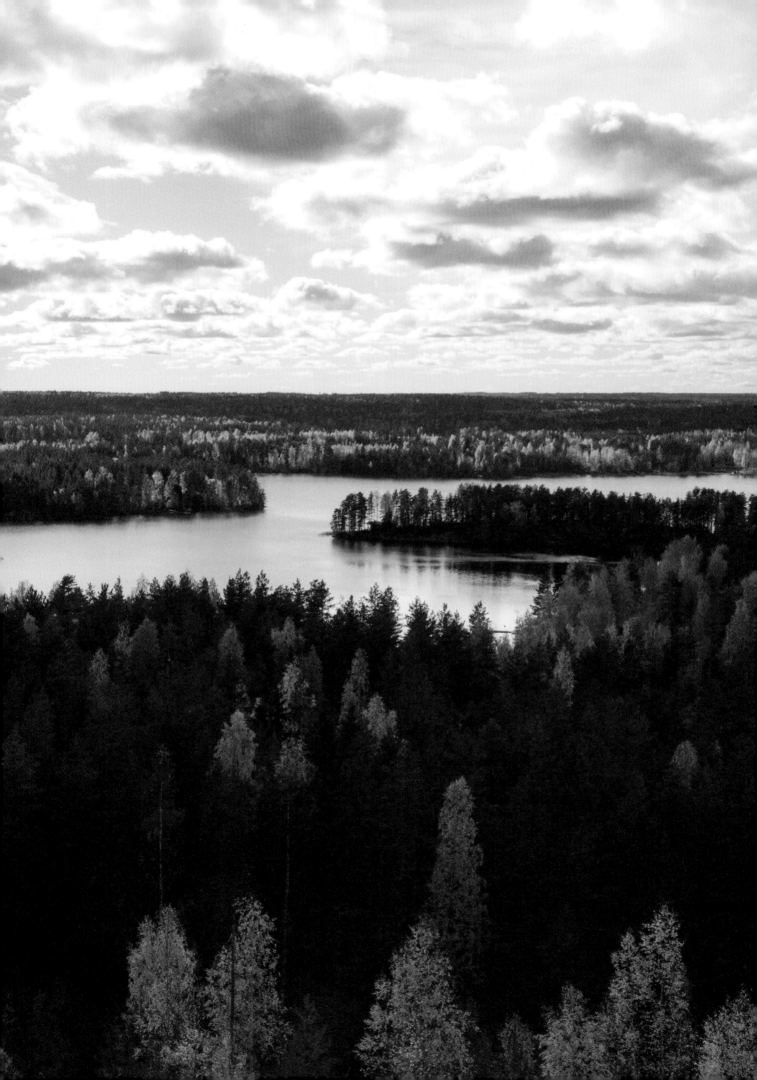

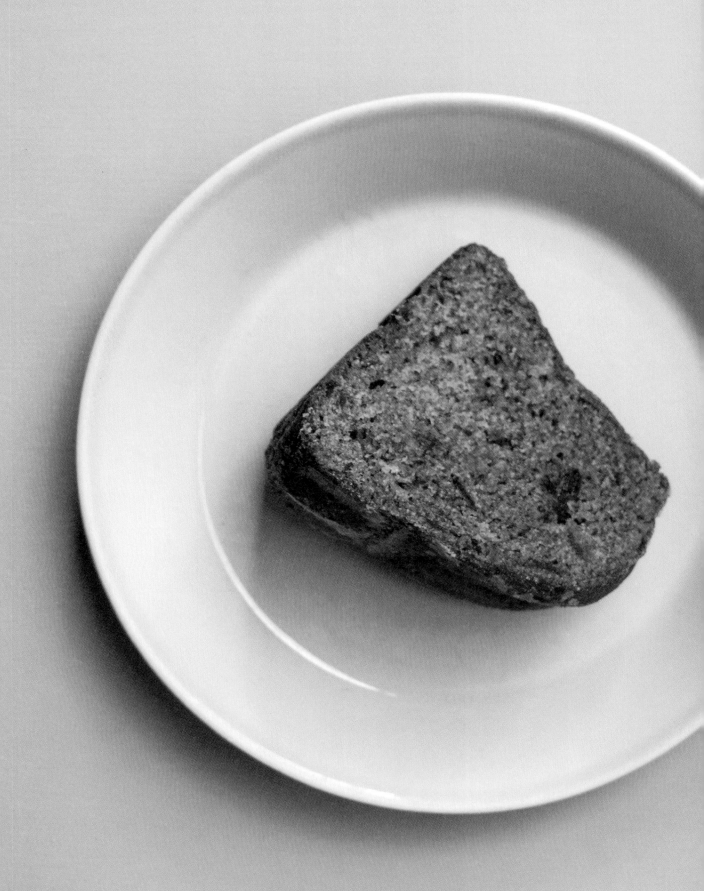

What you leave out is as important
as what you put in.

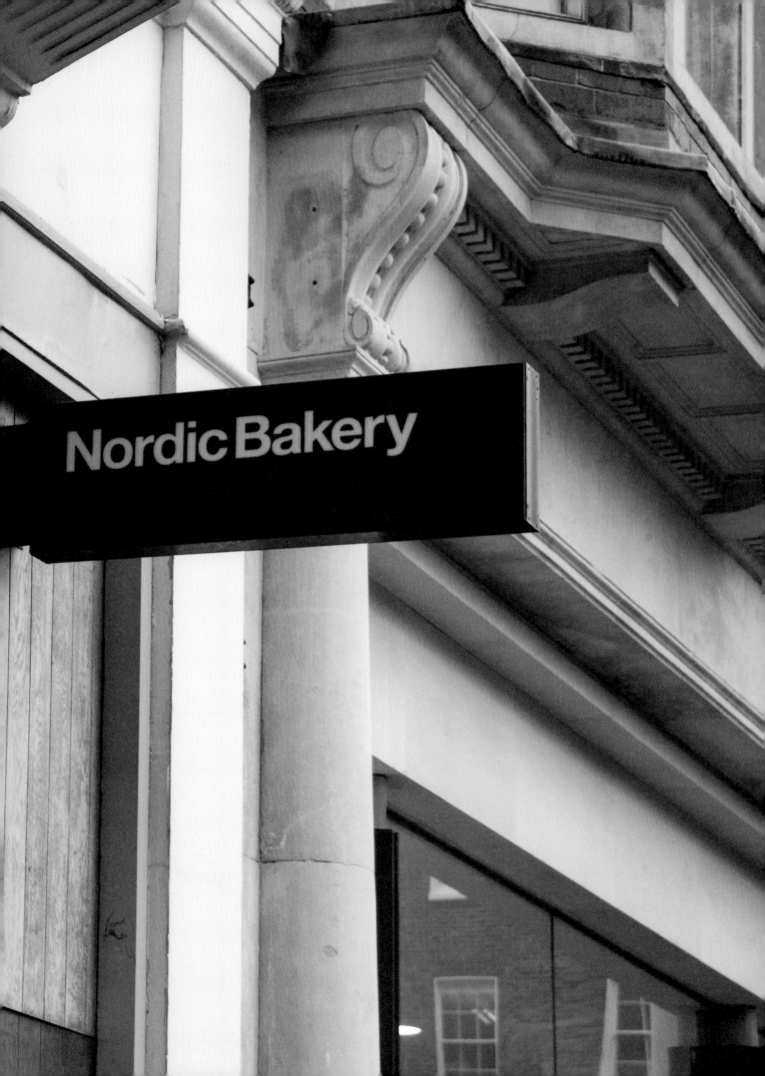

Font and flavour

Published by New Heroes & Pioneers

Photography by Milla Koivisto
Text co-written by Miisa Mink & Kathy Compton

Cover photography by Milla Koivisto

Creative direction by Francois Le Bled
Book design by Daniel Zachrisson
Edited by Francois Le Bled

Printed and bound by Lemon Print (Estonia)

Legal deposit and first edition published April 2017

Nordic Bakery® is a registered trademark

ISBN 9789187815843

On behalf of Nordic Bakery, I would like to thank the following people:

Milla Koivisto whose photography so beautifully captures the essence of Nordic Bakery; our
publisher Francois Le Bled, Kathy Compton for helping me to write this book in beautiful
English; Daniel Zachrisson for understanding the essence of our brand and his beautiful
book layout design; New Heroes And Pioneers for their professionalism helping us to create
this beautiful book; Rossana Consiglieri for impeccable project management and support;
Richard Keen who does extraordinary work managing all our stores; Jenni Saarinen and
Ionela Rusu for helping with the on-site photoshoots; Jaakko Tuomivaara who helped with
the book outline; our customers Cindy Cheung, Amira Alkhaja, Efe Çakarel, Bianca Wessel
for doing the customer interviews and for being such loyal customers; Mark Whitfield,
Charlotte Bland, Ugo Ottolenghi and Maud Davis for their contribution in our ideation
workshop for this book; Aten Marja-Aitta, Iittala and Hommanäs who are our suppliers and
contributed to this book; and also to all Nordic Bakery team members, bakers and baristas
that make Nordic Bakery the experience it is.

— Miisa Mink, co-owner, Nordic Bakery